The Healing Work of Art

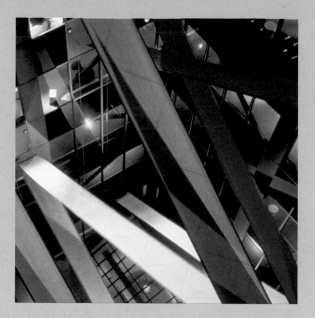

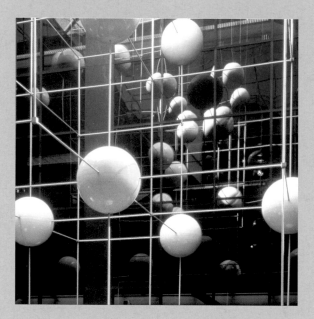

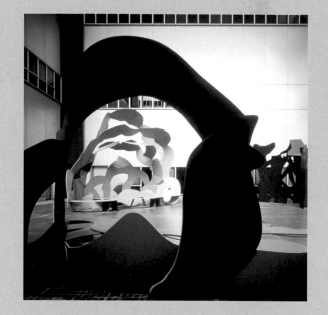

The Healing Work of Art

FROM THE COLLECTION OF DETROIT RECEIVING HOSPITAL

Letter from
Iris A. Taylor, Ph.D.

Foreword by
Graham W. J. Beale

Essays by
Irene Walt
Dr. Wilma Siegel

Edited by
Irene Walt
Grace Serra

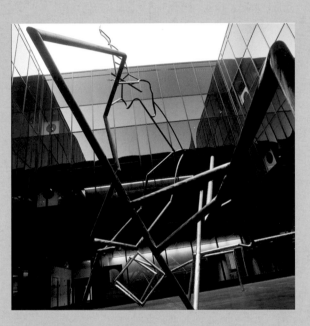

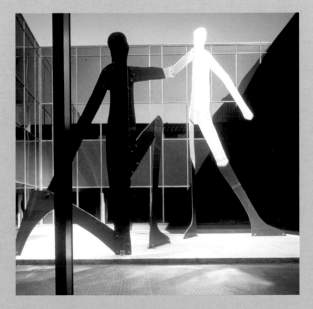

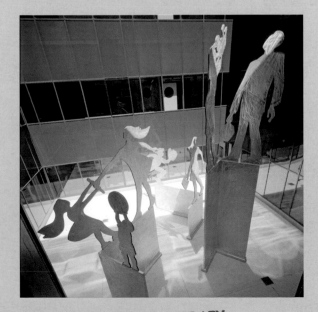

ISBN: 978-0-9798818-0-0

10 9 8 7 6 5 4 3 2 1

Detroit Receiving Hospital

4201 St. Antoine Blvd.

Detroit, MI 48201-2153

Front & Back Cover – *The Arc* by Diana Pancioli

Located at entrance of the University Health Center

Designed and typeset by Savitski Design, Ann Arbor, Michigan

Written and Edited by Cecily Donnelly, Ann Arbor, Michigan

Printed by University Lithoprinters, Ann Arbor, Michigan

Dedicated to Dr. Alexander J. Walt, my inspiration.

— Irene Walt

Letter from the Director

Since its inception in 1968 with one donated painting, the Detroit Receiving Hospital art collection—comprised of work that was either donated or specially commissioned over a forty-year period—has grown to include over 1000 works of sculptures, paintings, textiles and ceramics that enliven clinics, patient rooms, corridors, courtyards and public areas throughout the hospital.

From the beginning, art advisor Irene Walt has overseen the acquisition, funding, donation and installation of the collection, which was one of the first hospital art collections and, today, is one of the major hospital-based public art collections in the country. In 2000, artist Grace Serra joined Detroit Receiving as co-director and art advisor and the team of Walt and Serra continues to enhance the hospital environment with art, including this important art book initiative.

Bringing art into Detroit Receiving Hospital has opened doors to a new and expanding dimension in patient care. As the collection has evolved, numerous studies have documented the benefits of art to patients, families and care-givers in the therapeutic environment. Detroit Receiving has maintained its commitment to art in the hospital. We embrace the important role that art plays in the healing process by ensuring there are sufficient resources to maintain the current collection, acquire new art when possible and foster a sense of appreciation for the profound healing effect that art has on our patients.

Patients are more than their health conditions and symptoms and care-givers are more than their skills and training. Creating an environment that promotes healing goes beyond highly skilled care-givers and high-tech diagnostic equipment. Research shows that art may play a significant role in patients healing faster, requiring less pain medication and experiencing less stress. Staff is happier and more focused when in an environment that is energetic and rejuvenating and yet calming. I believe an art-enhanced hospital environment instills an on-going commitment to excellence in health care for our staff and places value on maintaining a caring attitude, humanity and a sense of community.

The Detroit Receiving art collection, as depicted in this wonderful book, is a source of great personal pride. I express my appreciation and gratitude to Irene Walt and Grace Serra for bringing beauty through art to our patients, visitors and staff and to everyone who contributed to the publication of our art book. I am honored to present to the community Detroit Receiving Hospital's *The Healing Work of Art*.

Iris A. Taylor, Ph.D. • President, Detroit Receiving Hospital

Foreword

If, as the Bard said, "Music hath charms to soothe the savage breast," what can be said for the visual arts? It used to be asserted that a picture was worth a thousand words and, while this can still be true, it's a long time since artists confined themselves to reproducing the world in front of them or depicting episodes from a larger narrative. Art now embraces an astonishing array of media and it is almost a cliché that art is what the artist says it is. But whatever the time, whatever the medium, artists have always sought to delve into the mystery of the human condition: from joy to fear; from peace to strife. And there is something special about a work of art itself that can rarely be conveyed through reproduction: the effort and love that went into the making and that remains in the finished piece. These objects are—to use a much misused word—unique.

One of the most consistent characteristics of true art, I am convinced, is that it is life- affirming. With a few notable exceptions a work of art will take an attentive viewer to a positive place. It illuminates the soul just as it brightens and enriches the space it occupies. This is the quality that Irene Walt's efforts have brought to Detroit Receiving Hospital. Through a program that started as an attempt to make a few wards and residents' quarters more cheerful Mrs. Walt and her colleagues have transformed the pallid corridors and rooms of a major public hospital into an Aladdin's Cave of vibrancy and delight. Certainly, as Mrs. Walt remarks in her introduction, not every work is for everybody but there is surely more than enough to distract and detain; to bring a strong dose of variety, surprise, and pleasure into spaces more usually associated with anxiety. The collection has become a model for others and has won a place in the hearts of those who visit the hospital, whether as patient, professional, or visitor.

Graham W. J. Beal

Graham W. J. Beal • Director, Detroit Institute of Arts

The Detroit Receiving Hospital Art Collection

THE HEALING WORK OF ART

My first sight of Detroit Receiving Hospital was in the fall of 1961, just off a plane from Capetown, South Africa with my husband and our three small children. My husband, Dr. Alexander Walt, had just been appointed to the surgery department at Detroit's Veteran's Administration Hospital following training in London and a four-year fellowship at the Mayo Clinic. As a medical student during World War II, he had served for three and a half years with field surgery units in Egypt and Italy. It was our first visit to Michigan, and although we did not know it then, in Detroit we had found our new home.

When Alec and I began our Detroit life in the 1960's, Detroit was a city in transition; it was a vital, struggling, sometimes chaotic, always interesting mix of forces reacting to the major economic and political events of the time—including the Vietnam War, the tragedies and achievements of the Civil Rights Movement, the riots of 1967, population shifts from the downtown to the suburbs, and a rapidly changing industrial economy.

The Medical Center, which included Detroit Receiving Hospital (founded in 1915 as a city-owned hospital), had filled a crucial role in Detroit's downtown and inner city since the creation of a first small hospital building in the 1880's. Detroit Receiving Hospital served the needs of the city's residents and had an excellent reputation, but the buildings were dreary and depressing; iron beds and old chipped furniture were the order of the day.

WE MUST TAKE CARE OF ALL

In July of 1967 the hospital community was severely tested by the riots, an explosive five day period of unrest that swept through the city; fourteen hundred people were injured. Detroit Receiving Hospital (then called Detroit General) was Detroit's urban trauma center, and during the rioting the message became clear: "We must take care of all." With his wartime field surgery training, my husband spent almost a week organizing the arrival of the injured and running a triage at the ambulance dock on Mullet Street. Eighty percent of those injured in the riots were treated at Detroit Receiving Hospital.

These events took a physical and psychological toll on the city and the hospital, but Detroit Receiving emerged from the experience as the city's major emergency hospital. The dedicated staff served the local population and achieved a first class trauma level 1 reputation. Today, Detroit Receiving Hospital maintains its reputation as a first-class emergency, trauma, critical care, and ambulatory care center and teaching institution. DRH is also known for its unique art collection, one of the first and largest hospital-based collections in the country.

A SURPRISING REQUEST

By 1968, my husband had become Chief of Surgery at Detroit Receiving Hospital. The hospital, which some called "The Old Gray Lady," had definitely seen better days. It was dismal and starkly utilitarian—imagine patients lying on metal cots in dimly lit, pea-green corridors. Alec asked me if I would see what could be done to improve the looks and function of the residents' quarters and eight residents' offices, and I was encouraged by the hospital's CEO Alfred Plotkin and Medical School Dean Dr. Ernest Gardner to form a committee. I was surprised at the request.

Although I was trained as a home economist I was a stay-at-home mother and not a decorator, more accustomed to separating eggs and three small children than to redecorating a hospital. I immediately began formulating a plan, which was the beginning of the "Beautification Committee" of the Friends of Detroit Receiving Hospital. It has been my delight and pleasure for nearly forty years to work to beautify the hospital and create our nationally recognized major public art collection.

Five extraordinary volunteers met every Tuesday for four years with a knowledgeable hospital administrator named Grovenor Grimes. Our group included Mary Alice Keast, wife of the President of Wayne State University, Sally Mayer, Norman Fink, and Moses Kelly Fritz. I discovered a new role as a passionate fundraiser; we met with many local foundations, men's and women's clubs, and other interested private citizens and friends. Their response was overwhelming and inspiring—we could never have done it without the many wonderful donors who contributed to this great effort over the years. We started raising funds, and our exciting work began.

What started as a project to refurbish a few wards and residents' offices in an old hospital building turned into a passion to bring color, art and serenity to patients and staff.

A HOSPITAL WITH HEART AND SOUL

I am extremely proud to have had the good fortune to work with a dedicated and effective group of volunteers and staff members in a hospital that truly has a great heart and soul and a mission to treat everyone regardless of ability to pay. I've been associated with the "Old Gray Lady" since 1968 (with time off beginning in 1984 to work on the Art in the Stations project for the Detroit People Mover). I cannot imagine a more rewarding career or a more wonderful group of people to have worked with. My husband used to tell me that I enjoyed my work so much that I should pay the hospital for the privilege of working there, and he was right.

I am grateful for the good will of successive hospital administrations whose understanding of the importance of art in the healing environment has enabled us to build this remarkable collection, and I commend the presidents of DRH under whose inspired leadership I've been privileged to serve. Edward Thomas taught me patience and the art of persuasion; Elliot Roberts was most helpful during our transition period; and Leslie Bowman's kindness and assistance eased our way through many difficulties. The leadership and guidance of current DRH president Dr. Iris Taylor have made the book "The Art of Healing" possible; her inspired support reflects a new era for art in healing.

Dr. Anna Ledgerwood and Dr. Charles Lucas assumed a leadership role in the sponsorship of this book. They contacted over seventy Michigan surgeons who had received their excellent training in the Surgery Department at Detroit Receiving Hospital. These DRH alumni "stepped up to the plate" as Dr. Lucas so plainly put it, with generous support for our ambitious project to celebrate the hospital's collection of art. Dr. Donald Weaver, Chairman of the Department of Surgery, has provided needed assistance and appreciation for the collection.

Grace Serra, who began work seven years ago as the Co-Director of the Art Advisory Program for DRH and the Detroit Medical Center, is to be congratulated on her enthusiastic curatorship, elegance of taste, and dedication.

Thanks also to my grown children, John, Steven and Lindsay, who were so gracious when pressed into service for DRH and other community art projects.

I particularly honor the hundreds of nurses, doctors and staff who have given their moral support over the years as Grace Serra, Terry Lee Dill and I marched through their working areas to install artwork, not all of which they loved at first sight.

Finally, I honor my late husband, Dr. Alexander Walt, for his passionate love of Detroit Receiving Hospital; he always wanted only the best for his residents, his students and his patients.

Irene Walt • 2007

In 1999, Irene Walt was awarded an Honorary Doctorate for Humane Letters by Wayne State University. She is the recipient of the Central Business District Association of Detroit's Heart of Gold Award for 1973, and the 2003 Governor's Award for Arts and Culture.

Changing the "Old Gray Lady"

When Irene Walt and the "Beautification Committee" began work in 1968, Detroit Receiving Hospital still had many cramped twelve-bed wards with dingy walls, iron furniture and few comforts. As the committee's refurbishing progressed through the hospital's staff and patient areas, it became more and more obvious that the committee had started a process that could not be stopped. "The response from doctors, nurses, hospital personnel and, importantly, from patients, was remarkable. Everyone had an opinion, not always positive but often passionate," Mrs. Walt says of those years.

By 1970, the committee had completely redecorated the women residents' quarters and kitchen and the nurses' locker rooms and lounge. They also provided the hospital's first elective surgery waiting room and blood bank donor lounge. The committee redesigned outpatient clinics and an oncology ward, created patient waiting areas and a children's play space, provided two completely new wards, and redecorated several others. They created a meditation room and waiting room for families of patients on the critical list. As each room or patient/staff area was completed, the committee asked a Michigan artist to donate a work of art.

Mrs. Walt first encountered art in a hospital setting in 1952 during Dr. Walt's fellowship at The Mayo Clinic, which has a large art collection. "Art was always very important to me, but I was not yet a collector or trained in art acquisition. I had on-the-job training," she says, "we all did. Before long we had 200 works of art on the walls, most by Michigan artists."

"The first painting we hung—of boats on Lake Michigan—was donated by Michigan artist Marjorie Hecht. That painting still hangs in the hospital today, along with several others by the same generous artist. Our first site-specific work was commissioned from sculptor Harry Bertoia, who taught at Cranbrook Academy of Art. That piece, constructed of brass rods that made playful music when touched, was especially created for the meditation room. It was so appealing for patients to pull down the brass rods to make music that we had to send it back twice to the artist for repairs. It now stands safely in the hospital's administration offices.

"One of our earliest projects, the St. Antoine Park, was created on a small police department parking lot across

the street from the hospital. Led by James Cardoza of Kessler Associates, together with the Hospital Service League, we built and landscaped the park and managed it for patients, staff, and visitors for several years until, unfortunately, a new jail was built on the site."

A NEW HOSPITAL AND A NEW ARTS COMMISSION

In 1980, Wayne State University and Detroit Receiving Hospital began making plans to construct a new Detroit Receiving Hospital in the Detroit Medical Center across from Wayne State University's School of Medicine. The architect, William Kessler, was passionate about making art integral to his buildings, and he asked Irene Walt to help form a committee to work with him to choose major works of art for the new building. Mayor Coleman Young and Wayne State University President George Gullen each appointed four members to a new Joint Art Commission charged with overseeing artwork acquisition and placement. Commission members were also asked to take on the huge task of funding and implementing the ambitious project.

The eight members appointed to the Joint Art Commission were chairperson Olga Dworkin, who was also chair of Wayne State University's beautification committee; architect William Kessler; attorney Eugene Driker; Director of European Art Dr. Dewey Moseby of the Detroit Institute of Arts; art consultant Lee Hoffman; Wayne State University art professor Richard Bilaitis; Dr. Harold Gardner of the WSU Medical School; and Irene Walt. These dedicated volunteers, each with a special expertise to bring to the endeavor, created for Detroit Receiving Hospital what is now one of the outstanding hospital-based public art collections in the nation. The Commission, spearheaded by Olga Dworkin and Irene Walt, raised over half a million dollars to fund the collection and many smaller collections.

"NOTHING IS TOO GOOD FOR US."

The hospital building designed by William Kessler and Associates was one of the nation's first hospitals devoted solely to adult emergency and trauma care. The building's unique design has been recognized with numerous awards, including one from the American Institute of Architects (AIA).

▲ Harold Neal and Irene Walt

▲ Irene Walt and Kirk Newman

▲ Installing *The Family at Work and Play*

As hospital construction proceeded, the committee began commissioning artwork for the courtyards and important interior spaces. They visited artists' studios and invited artists to Detroit to consult. As art was chosen, approved, commissioned, funded, and created and the installations began, committee members soothed artists' nerves, attempted to reconcile artistic visions with the concerns of hospital administrators, architects, facilities managers and staff—not always an easy task—and kept the project moving forward in spite of sometimes major obstacles and delays. Cranes were required to lift large sculptures over walls and into interior courtyards, walls had to be reinforced to accept heavy installations, there were inevitable delays, revisions and negotiations.

The unique Detroit Receiving Hospital art collection, which now numbers over one thousand pieces, has evolved over time to reflect the personality and spirit of its host building and city. It currently includes a collection of African, Asian, and South American textiles; African masks and beadwork; contemporary paintings; prints—including some fine prints on permanent loan from the Wayne State University collection and 130 interesting prints donated by Detroit art dealer Peggy DeSalle; a commemorative Michigan quilt; a major sculpture collection; mobiles; and Pewabic tile installations. The concept of art as an integral part of the healing environment is now well established and documented, but in the 1970's and 1980's, some saw the art project as purely decorative.

"Through it all, the hospital administration remained supportive of our goals. One of the very important roles the members of our committee embraced was to communicate our belief in the healing power of art to the other members of the hospital community. There is tremendous pride of ownership now among staff, alumni, and patients in the hospital's art collection. Not everyone likes every piece on every wall, but they are proud of what we have and the statement it makes about the value we place on their working and healing environment."

AN IMPORTANT COLLECTION

"When the art commission began its work, architect William Kessler pointed out that there were seven courtyards and many public areas that would need major works of art," Walt remembers. " One of the committee members, art consultant Lee Hoffman, had a wonderful knowledge of contemporary art on the national art scene. She was our 'taste-

▲ Diana Pancioli

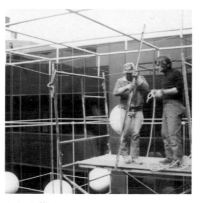
▲ Installing *111/4K*

▲ George Sugarman

maker' and helped us to think nationally in our quest for major artists and installations for the new building. She visited New York often to advise clients in the Detroit area, and she brought prominent names to our attention. As we worked to create a great collection, we became experts in our field."

By 1983, seven important commissions—by artists Sam Gilliam, Anne Healy, Richard Hunt, William King, Joseph Kinnebrew, Glen Michaels, and George Sugarman—had been installed in the hospital courtyards and public areas. "The Family at Work and Play" by sculptor Kirk Newman was completed and installed in the remaining courtyard in 1990, and other major commissions, including "The Arc" a ceramic mural by Diana Pancioli, were commissioned and installed.

One of the artists approached by the committee was Washington painter and sculptor Sam Gilliam. "We had commissioned Sam Gilliam to create a major wall installation, and flew to D.C. to spend two days in Sam's studio as the work progressed. We watched with great excitement as the new piece was loaded on a flatbed truck for its trip to Detroit." Gilliam's seven foot by thirty-six foot acrylic "Wave Composition" was one of the artist's earliest public art commissions in a distinguished career which now includes works in most major museums and many public spaces.

"Sam Gilliam stayed in our house during this installation. The commission members had many of the artists as house guests, because we had decided that we would be their hosts in our city. One day as Sam and I were having coffee at my house I timidly said to him 'Don't you think that red metal piece should be a bit closer to the major part of the work?' He slammed his hand down on the table and said to me: 'Do I tell you how to cook?!' He did later say that he wanted me to have the maquette for the piece, and I have treasured it.

"When William King was here to install his sculpture "Help," we had to have wet white cement carried in wheelbarrows over the new carpeting to create a cement base in the middle of the courtyard. The Joseph Kinnebrew sculpture "111/4K," which consists of twenty-four giant aluminum spheres supported by a grid that fills a five-story courtyard, caused some real problems during installation. A wind tunnel was created in the courtyard, and the spheres and wires swayed so much at first that we were afraid we'd lose a window. And when Kirk Newman's "The Family at Work and Play" was installed, Grace Serra and I watched with trepidation as giant cranes lifted entire portions of "the family" up over the hospital and lowered them gently into the courtyard.

▲ William King

▲ Glen Michaels

▲ Coleman Young and Carl Levin

"I took it on myself to be there nearly all the days when work was being installed," says Walt. "At times, tempers had to be cooled. But it was an exciting and wonderful time."

As Lee Hoffman noted in a Detroit News interview, "When you work with artists and installations, there can be big problems—that's where Irene was so incredible, nothing stood in her way. The obstacles were unbelievable, but Irene and Olga Dworkin were always positive and cheerful."

THE EVOLUTION OF A COLLECTION

In 2000, Irene Walt was joined by Art Advisor and Co-Director Grace Serra. "As the collection continues to evolve and grow, Grace and I have traveled, sought out and found many wonderful Detroit and Michigan artists who add zest and individuality to the collection. Being an artist herself, Grace has been instrumental in finding young and interesting artists for the hospital." Together, Serra and Walt have commissioned and installed major pieces as well as adding to the many smaller works that brighten and energize the hospital's corridors, treatment areas and patient rooms.

After Detroit's Renaissance Center was purchased by General Motors for its new world headquarters, artist Glen Michaels discovered that the Comerica Bank center on the second floor was to be moved and that his 130 foot assemblage tile wall would be destroyed by the next morning. With great assistance from United Community Services Chairman Milton Zussman, Carole Arcy, Lisa DiChiera and the Comerica Bank, Michaels was able to save the large wall mural from destruction. It was then donated by Comerica to the Art Department at DRH to be used for six separate installations. One segment went to the Wayne State University School of Medicine. Others went to the Shifman Medical Library; the Helen Vera Prentis Lande Medical Research Building, Wayne State University School of Medicine; the new Emergency Room at DRH; and the Henry Ford Health Care System.

In 2005, as a new emergency department was being planned, the art department was invited to participate and make suggestions "One of our projects was to commission Pewabic pottery to create a large, colorful mural at the entrance of the Emergency Department," says Walt. "Their handsome tile mural in blues and greens graces the waiting area and an exotic tile flower mural by Jeff Guido of Philadelphia invites patients inside. The E.R. was one of the first

▲ William Kessler

▲ Richard Hunt

▲ Roy Slade and Sam Gilliam

in the country to use lighted photomurals as ceiling panels in patient areas. Balthazar Korab's photos of the natural world give patients a peaceful view to counteract their stress."

Several other major works in the emergency area include a black and white Charles McGee sculpture, a large Carol Harris quilt of the Detroit skyline, a fine Allie McGee painting, and a significant June Kaneko sculpture.

Detroit Receiving Hospital was one of the founding members of the Society for the Arts in Healthcare, now an influential international professional organization, and DRH is known and respected for its early commitment to the arts in healing. "I am very proud to have assisted in the birth of this important movement, and most grateful to have had the opportunity to help create the unique and powerful public art collection at DRH. I believe we have one of the finest hospital art collections in the country because so much loving care went into each selection. And we're not finished yet!"

Art from the Heart

A t Detroit Receiving Hospital, the Mayo Clinic and some other hospitals and medical facilities, forward-think-ing people like Irene Walt came to an early understanding of art's important role in the healing process and began to place artwork in hospital spaces to provide inspiration and relief from the sometimes dehumaniz-ing technologic atmosphere of the medical setting.

I have always been aware—as a pioneer physician working in oncology, hospice care and AIDS care—of the enormous value of art and creativity. Managing a dual career as an artist as well as a public health professional, I have consistently used art to learn about the human condition. Through the process of making art, I have been able to become more creative in my medical profession. In the discovery of how art can help make us better healthcare givers, I became pas-sionate about connecting this knowledge further to the healthcare world.

In the 1970's, my mentor, Alma Dea Morani, M.D. (the first woman plastic surgeon in the U.S., the first woman trained as a surgeon at the Mayo Clinic, and the daughter of a sculptor) started a hospital art gallery dedicated to healing art. During the same time, world-renowned radiotherapist Dr. Luther Brady began bringing high-level art in the form of periodic exhibitions into his clinics. Since the founding of the Society for the Arts in Healthcare in 1991, there has been a major growth and proliferation of healing art programs throughout the United States.

As the benefits of a creative physical environment on the health and well-being of medical patients and staff have become widely recognized and established, another aspect of art in healing has emerged — the great therapeutic benefit of art-making itself, both in the education of physicians and medical professionals and in patient therapy. At Medical College of Pennsylvania, medical students are taught art by an artist in residence. Commonweal in Cali-fornia has been a major forerunner in the field, and at the University of Florida, Doctors Graham Paul and Mary Lane have created an artist-in-residence training program at Shands Hospital. Columbia Medical Center and other facilities

throughout the country have instituted collaborative programs. I consider this collaboration between creativity and healing to be "compassion, communication, and creativity."

For the past five years, my passion has been to bring art together with health care education and practice. Artists and healthcare professionals should approach art not as static work placed in the rigid venues of galleries and museums, but as a part of daily life. Artists can be healers through their work and healers can use art to focus on the deep creative dimension of people.

I hope that we will continue to appreciate the value of art and work with artists to lift the human spirit in health care settings, on city walls, and in all living spaces where people congregate.

Finally, I would like to end with a thought from Yehudi Menuhin, the great violinist. He said, "Let us keep open the connections whereby the human spirit may freely move between the arts and sciences and thus make more of each. May we thus become better violinists, scientists, caregivers, artists, writers, and above all, better human beings by enlarging and enriching our personal needs to include each other's."

Wilma Bulkin Siegel, MD • 2007

Wilma Bulkin Siegel, M.D., spent her career treating women with breast cancer, and is a pioneer in the hospice movement, and, in so doing, became a pioneer in the treatment of dying AIDS patients. She is a recognized portrait artist.

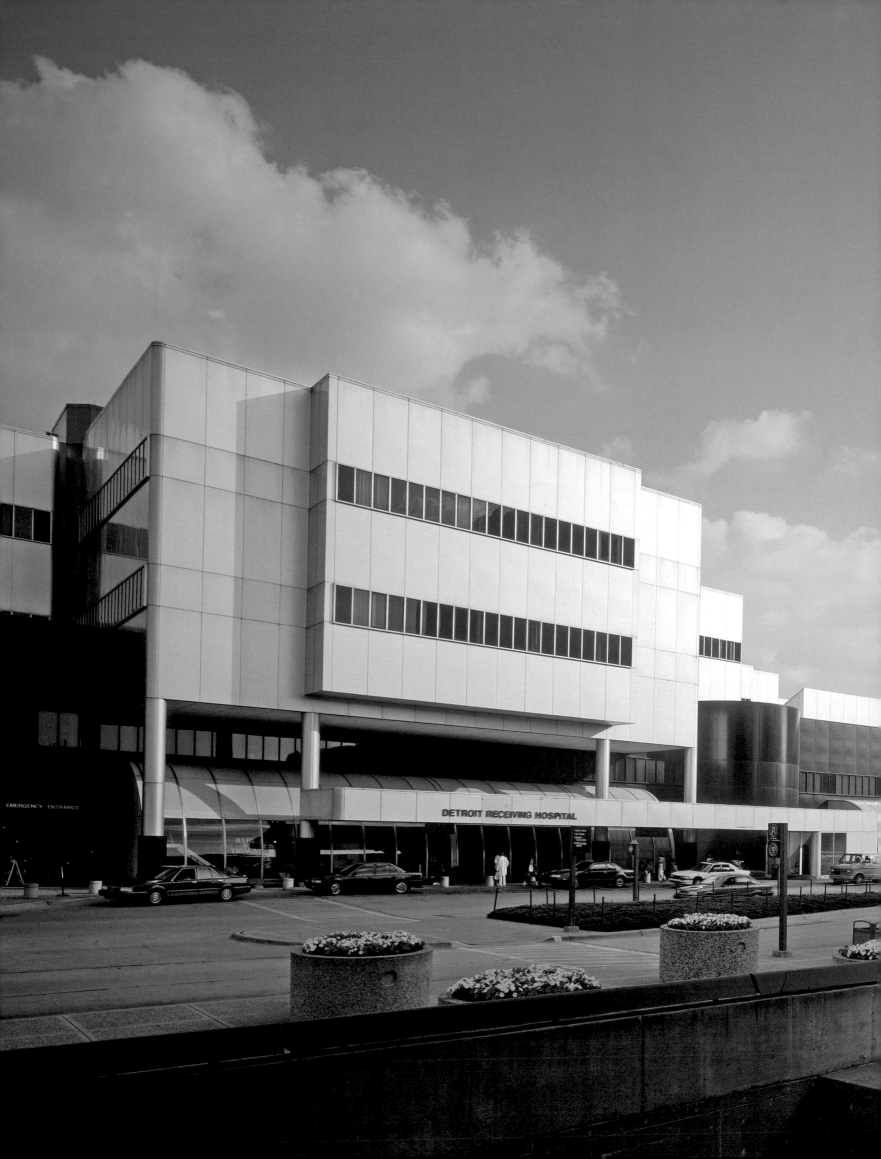

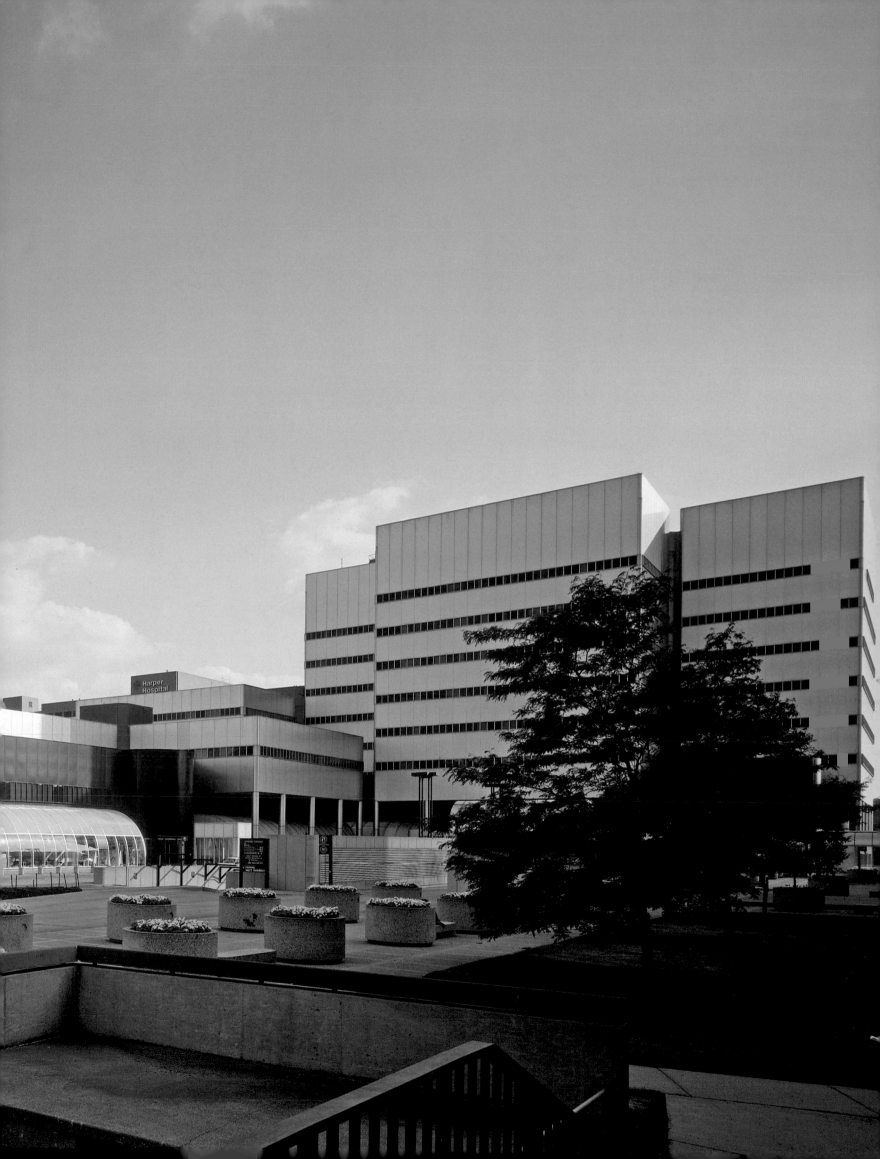

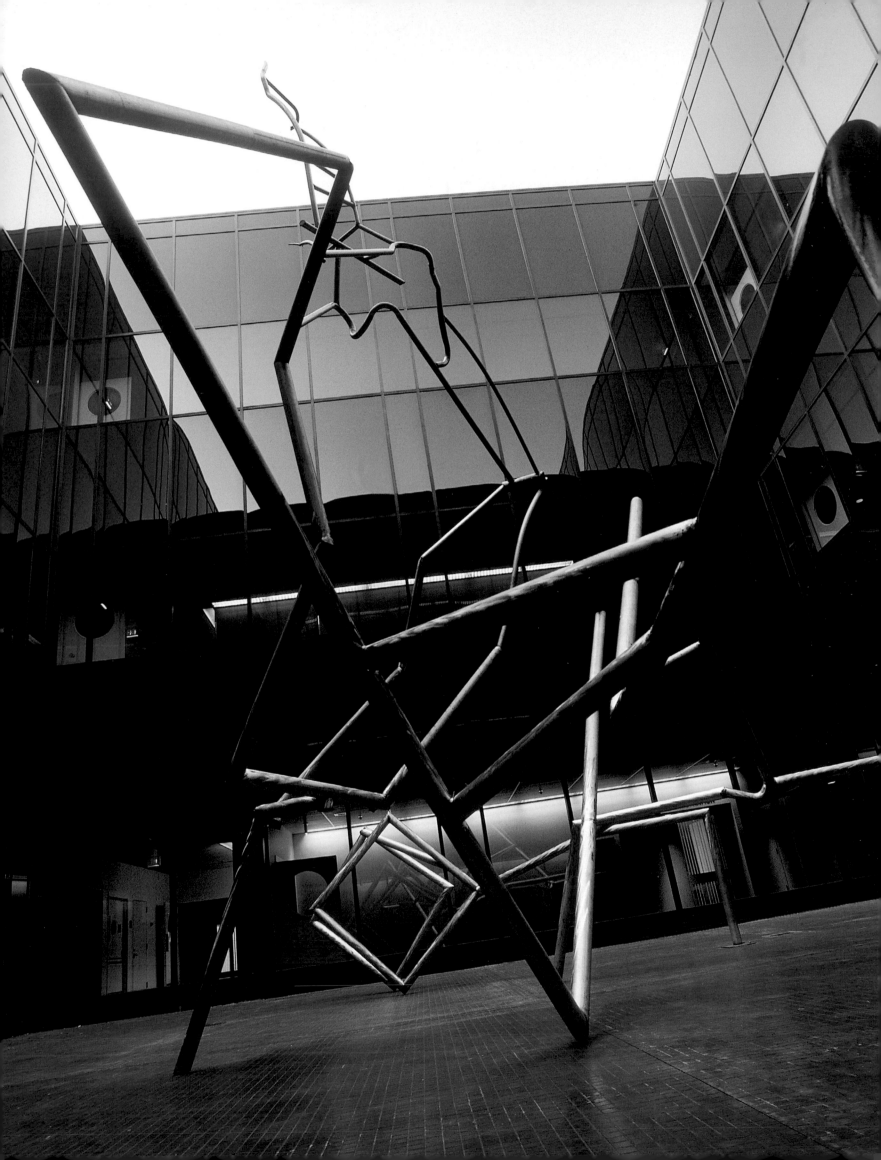

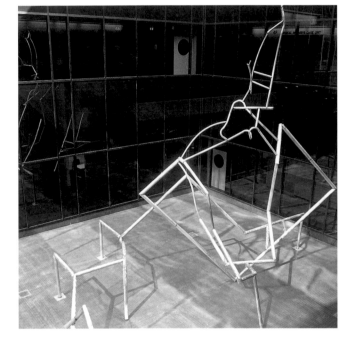

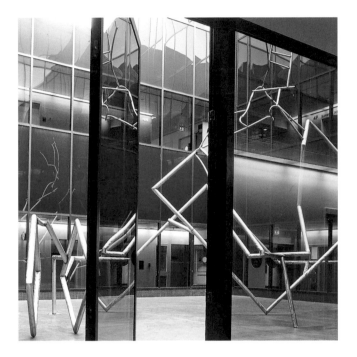

Richard Hunt • **GIANT STEPS** • Painted Steel • Four Story Hospital Courtyard

This free-standing sculpture of three-inch diameter stainless steel tubing rises forty feet above a third floor courtyard. It is an expressionistic reference to a natural form. The top of the work is crowned by antlers as often found in African artwork, and influenced by the artist's collection of African art. The work of Chicago artist Richard Hunt (both work on paper and public and gallery sculpture) is recognized nationwide and is represented in museum and public collections. This monumental contribution to the DRH collection was named "Giant Steps" after a well known jazz composition by John Coltrane. The name is also identified with Mayor Coleman Young, who as Detroit's first African American mayor made "Giant Steps" in the civil rights movement and in running the City of Detroit. "Giant Steps" was commissioned to honor Mayor Coleman A. Young and was funded by the Friends of Mayor Coleman A. Young in 1982.

Allie McGhee • **EGYPTIAN FIGURE** • Oil on Canvas • 5' x 7' • Level One

One of Detroit's leading artists, Allie McGhee has created large-scale public commissions for the Detroit Institute of Arts, Bishop Airport (Flint), Detroit's Northern High School and the Michigan Avenue People Mover Station, among many other sites. He partnered with historic Pewabic Pottery in Detroit to learn how to translate his paintings into a durable tile medium for the Detroit People Mover Project. This work is one of a series, and was commissioned and donated by "New Detroit" in 1967.

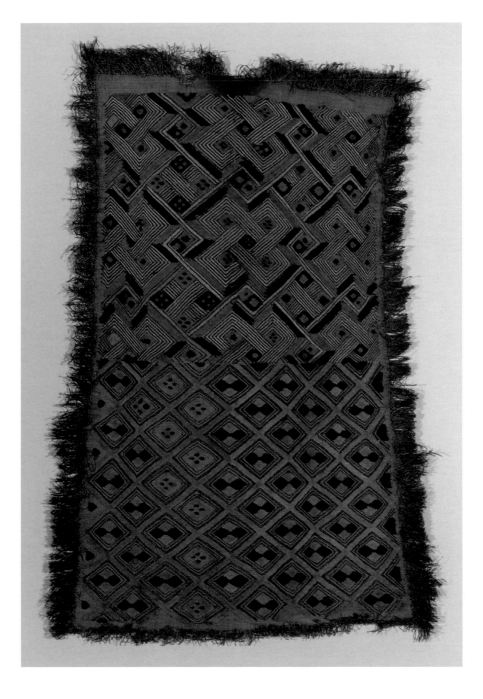

Unknown Artist · **SHOWA/KUBA CLOTH** · Textile · 30" x 56" · Level Two Corridor

The Kuba people of Zaire are known for intricately embroidered ritual cloth of raffia. In Kuba culture, the men weave the plain ground fabric, and the women ornament and applique the textiles with imaginative geometric patterning, sometimes called "Kassai Velvets." The Kuba surround themselves with a sophisticated vocabulary of elaborate decorative patterns found in architecture, basketry and body scarifications.

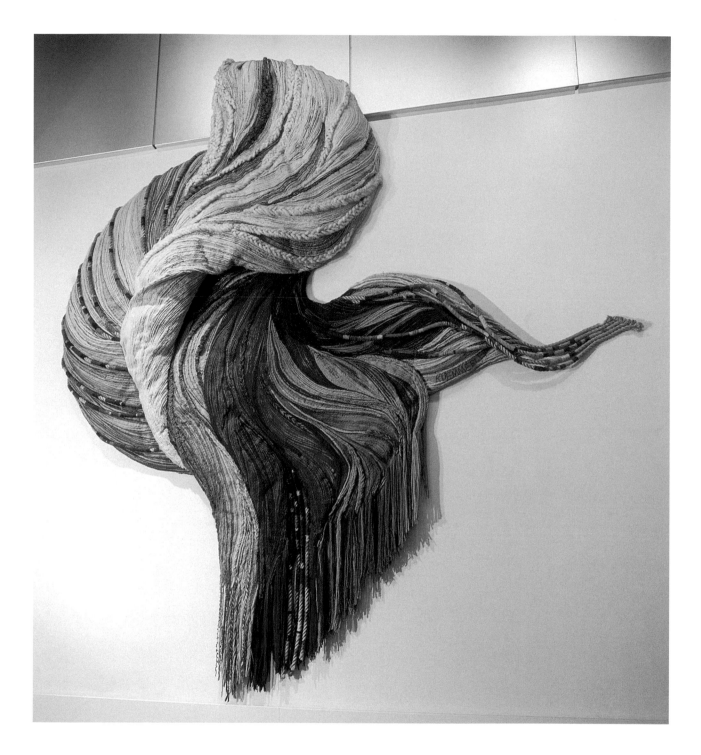

Janet Kummerlein • **TRITON** • Textile • 12' x 16' • Second Floor Main Corridor

Kummerlein, a nationally known textile artist and Kansas City resident, is a former Detroiter who attended Cass Tech, the College of Creative Studies and the Cranbrook Academy of Art. Her work is included in the Chicago Art Institute Permanent Textile Collection, U.S. Federal Building, Alaska, The Museum of Contemporary Crafts, New York, and The National Collection of the Smithsonian Institution. Her work has won numerous Art in Architecture Awards, Religious Art Awards and Artist-Craftsman Awards. Janet Kummerlein was invited to come to DRH to re-install this work in its new location after it was donated to the DRH by the Novi Hilton. The spiral conch-like sea shell held by the mythological Greek sea god, Triton, inspired the design of the abstract free-form sculpture. The colors within represent nature: brown and beige, the winter or dormant stage; the reds and oranges explode with the growth of summer and the whites and lighter colors depict peace. It weighs over 200 pounds and incorporates various yarn techniques: stitching, wrapping, braiding and padding. Donated by the Novi Hilton.

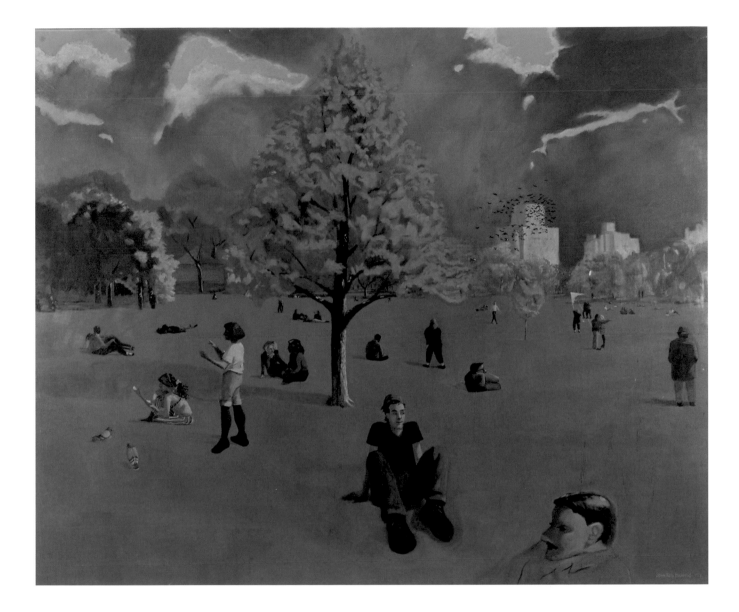

John Michaels • **CENTRAL PARK** • Oil • 72" x 84" • Level One

John Michaels, a native Detroiter, now lives and works in New York City. Michaels' work often reflects people at rest, in parks, or bathers on the beach; this painting of New York's Central Park shows people relaxing in the afternoon. Michaels has exhibited in New York and is currently showing in Germany, where his Long Island beaches and New York City views are collected.

Collin Thomson • **Dragon** • Oil • 70"x 68" • Level One

Colin Thomson is a New York artist who trained at Yale University and the New York Studio School. He received a National Endowment for the Arts Fellowship, and has exhibited his work throughout the United States. His paintings develop imagined combinations of subject matter and space, finding an open path between figuration and abstraction. Donated by Dr. & Mrs. Alexander Walt.

Jun Kaneko • **UNTITLED** • Ceramic • 13" x 24" x 13" • Level Two Lobby

An internationally renowned ceramic sculptor born in Japan and now living in the U.S., Jun Kaneko was Artist in Residence in Ceramics at Cranbrook Academy of Art. His work, including a complex tile mural installation in the Broadway Station of the Detroit People Mover, is in many important private and public collections. Kaneko credits Detroit for his first public work of art. The small-scale Kaneko work in the DRH collection may have served as a maquette for the heroic-sized pieces he creates today. Gift of Mr. & Mrs. Fred Erb, Edgemere Enterprises.

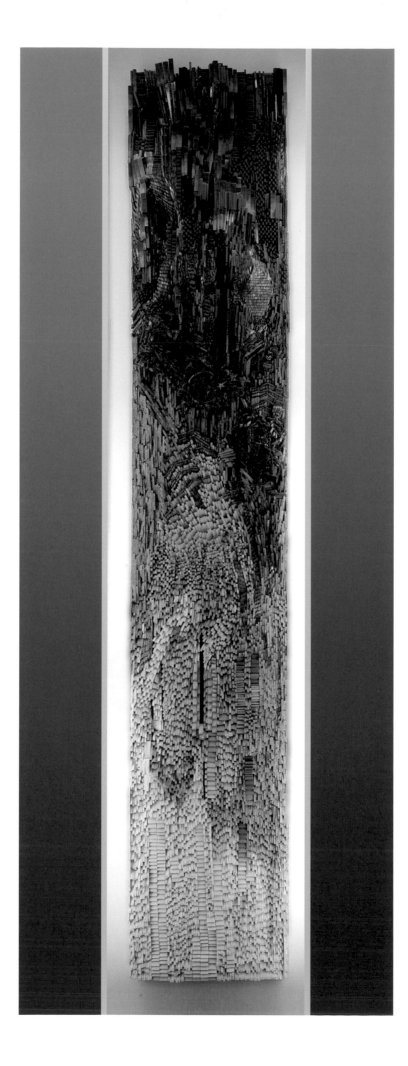

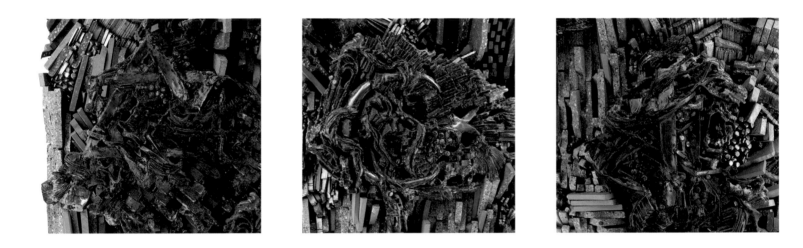

Glen Michaels • **INTERDENOMINATIONAL ALTAR PIECE** • Assemblage • 108" x 19" • Level Two

This Mediation Room centerpiece incorporates symbols of world religions: a Star of David for Judaism, the cross of Christianity and the crescent moon of Islam. Reference to nature is made through the arrangement of the various materials that seem to flow like a river. Nurses who worked as volunteer apprentices in the cutting and sorting of the small tiles for the piece were: Barbara A. Hatcher, Dawn Hency, Helen E. Johnson, Betty R. Skomski, Mary Patricia Wilcox, and Tricia Yulkowski. The work was created in honor of Marianne Lieber. Donated by Peggy DeSalle, Bronze Casting; Mrs. Robert R. Ferguson, Printer's Reglets; C.W. Maine and Sons, Woodworking; Hank Marx, Lead Type; Fred Blackwood, Tile; Homer Wagman, Ivory and Ebony.

Vassely Ting • **FIRECRACKER** • Oil • 38" x 52" • Level Two Meditation Room

Vassely Ting is a well-known California painter. This blue tone painting adds serenity to the meditation room where peace and quiet are vital to visitors and patients. Gift of Jean & Joseph Hudson of Detroit.

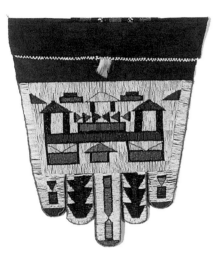
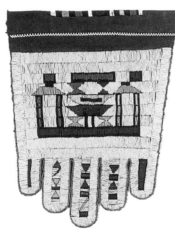
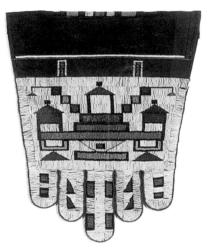

Unknown Artist · **NDEBELE APRONS** · Beaded Materials · Main Lobby

The Ndebele aprons are items of ceremonial clothing that are made of animal skins covered in beading. The small aprons are also used for children on ceremonial occasions.

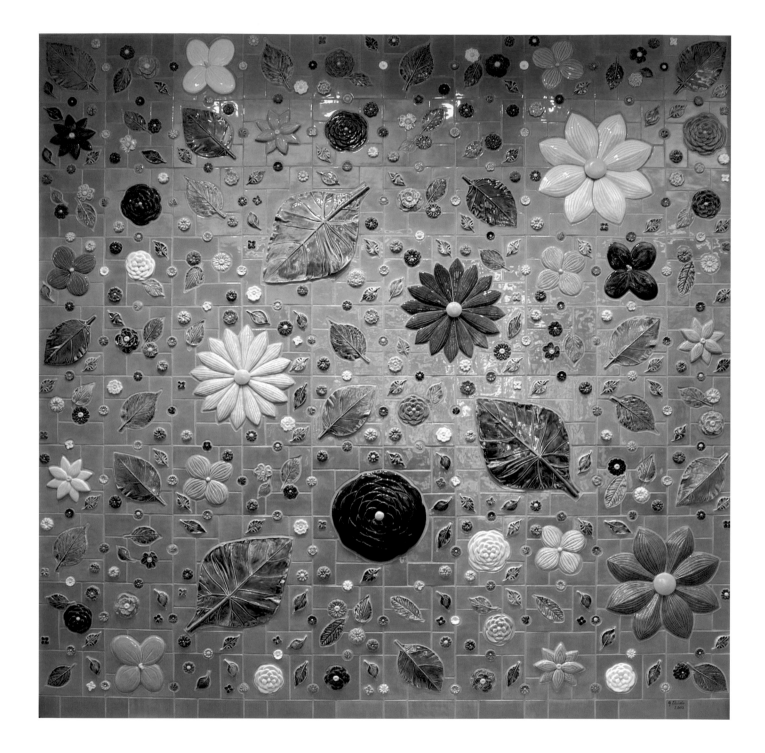

Jeff Guido • **FLORA** • Ceramic Tile • 120" x 120" • ER waiting

Guido trained at Wayne State University, and is the former gallery director and director of the design studio at Detroit's historic Pewabic Pottery. Jeff was a partner in Guido/Shaw Clay Gallery and is now artistic director of the artist-in-residence program at the Clay Studio, Philadelphia, PA. Every piece of this work is hand made and installed by the artist. This exuberantly colorful site-specific tile work brings joy to patients and their families who visit the Emergency Room, and was included in the emergency department's 2004 expansion project.

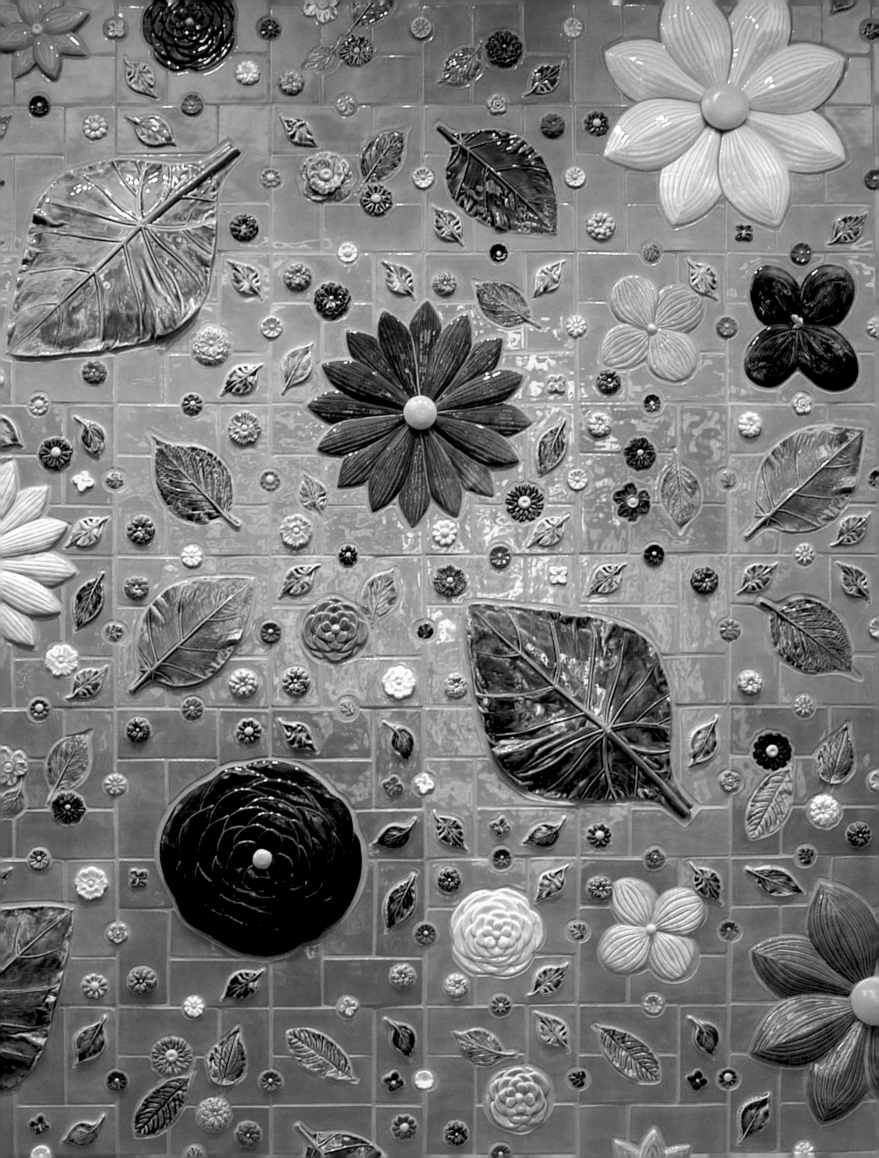

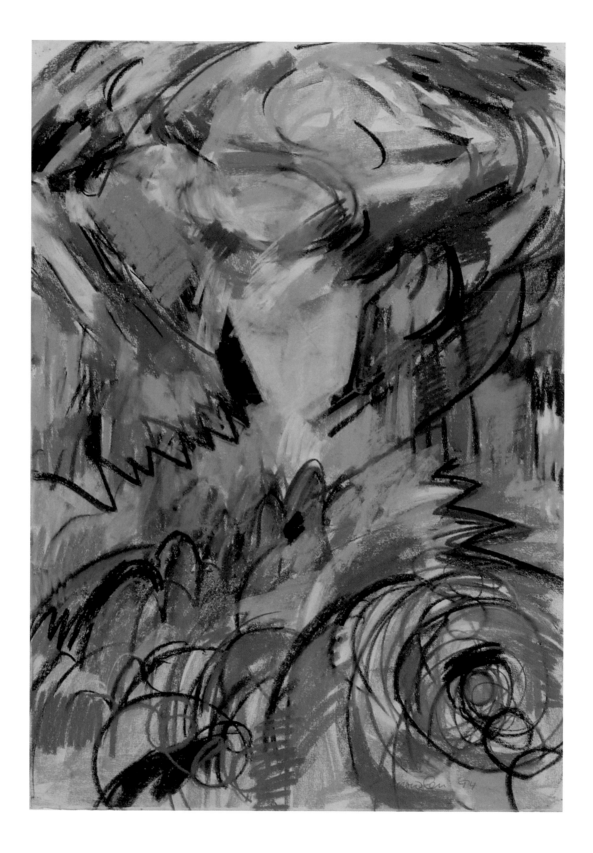

Gilda Snowden · **TORNADO** · Pastel · 40" x 56" · Level Two

Gilda Snowden is a Detroit artist who trained at Wayne State University and teaches painting at the College of Creative Studies. This work, using the bold colors of a storm-tormented sky, demonstrates Snowden's ongoing fascination with tornado imagery. Her work is well-represented publicly and is included in the collection of the Detroit Institute of Arts.

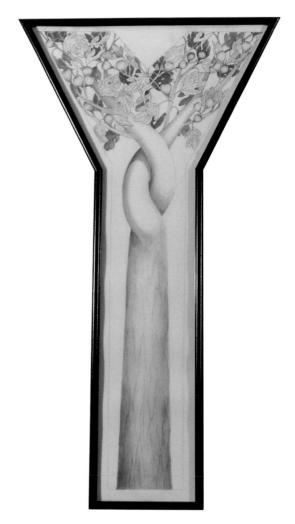
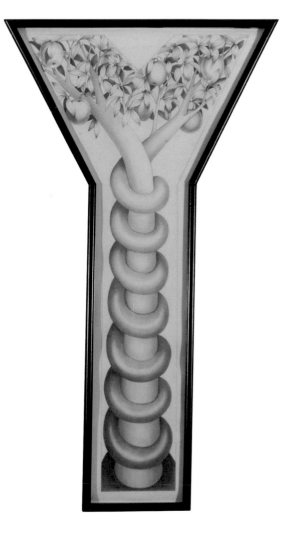

(Left) Grace Serra • **TREE OF LIFE** • Graphite Drawing • 48" x 12" • Level Four

(Right) Grace Serra • **TREE OF KNOWLEDGE** • Graphite Drawing • 48" x 12" • Level Four

These drawings address the connection of the symbolic representation of tree imagery between various cultures and religions throughout human history. They are reminiscent of the Garden of Eden and the tree of life. Serra, a Detroit artist, trained in Florence, Italy and has exhibited her work throughout the Midwest. Donated by Dr. & Mrs. Alexander Walt.

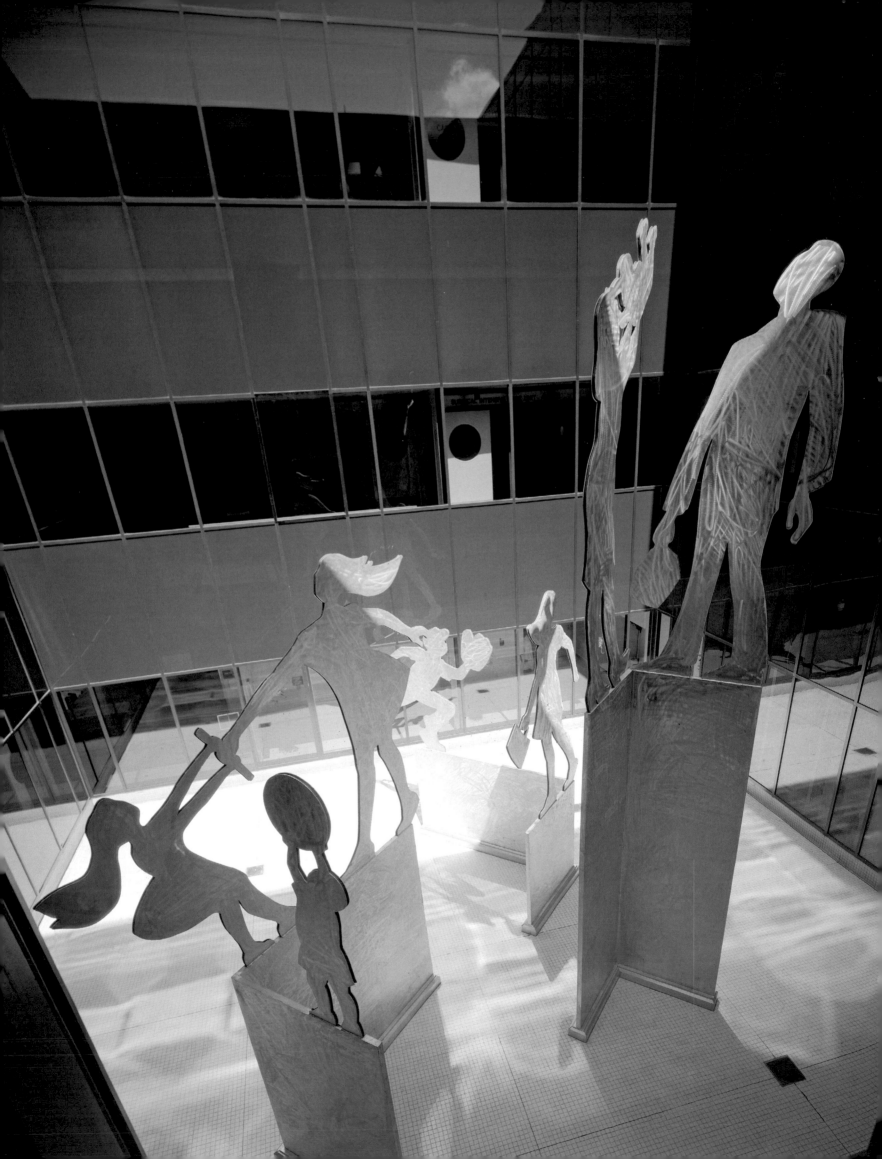

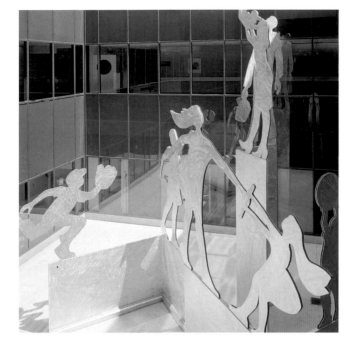 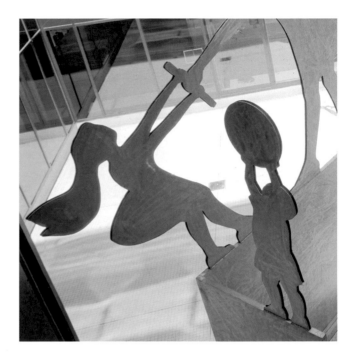

Kirk Newman • **THE FAMILY AT WORK AND PLAY** • Aluminum • Four Story Hospital Courtyard

A most human work that celebrates the family, Kirk Newman's treated aluminum sculpture shows seven figures — a mother, father and children in various modes of work and play. The tallest figure rises 32 feet in the courtyard. The members of the family are on ten foot aluminum stands fabricated at right angles to each other; shadows cast by the various parts of the sculpture are an important and changing element of the work. Michigan artist Kirk Newman has exhibited widely both in the U.S. and abroad; his work uses realism in new and original ways that relate to the contemporary world. He brings to the work an interest in physics and anthropology. For the Michigan Avenue Station of the Detroit People Mover, Kirk Newman created a large wall of eight figures running upstairs. Funding was provided by the Michigan Council for the Arts and Cultural Affairs, the alumni of "Old" Detroit Receiving Hospital, the Kasle Foundation, the Detroit Receiving Hospital Fund and Detroit Receiving Hospital staff and friends.

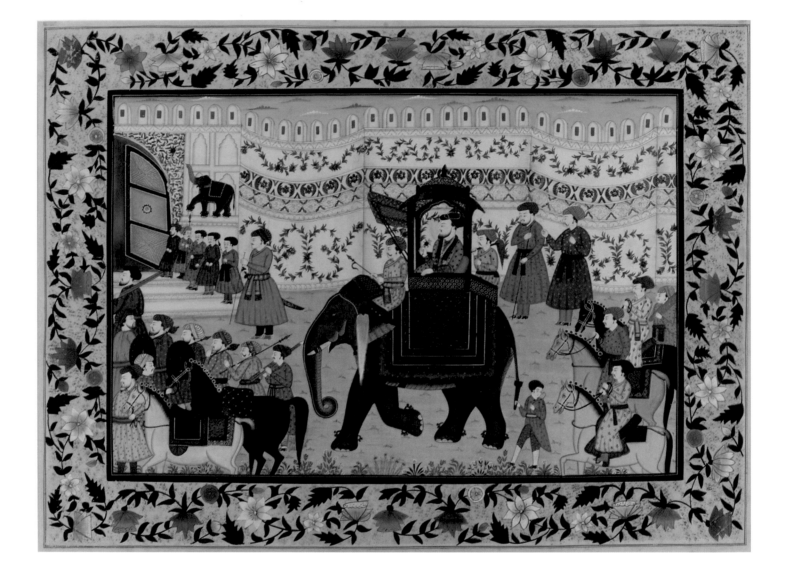

Unknown Artist • **INDIAN PRINT** • Silk Painting • 53" x 41" • Level One

These works, selected by the artist Marjorie Hecht Simon on a visit to India, are meticulously painted on silk and portray animals, pageants, horsemen, elephants, colorful court clothing and scenes of daily life. Depicting a familiar theme in Indian art, they provide insight into the ceremonial rituals of India and are reminiscent of early Persian paintings while remaining true to familiar scenes witnessed each day.

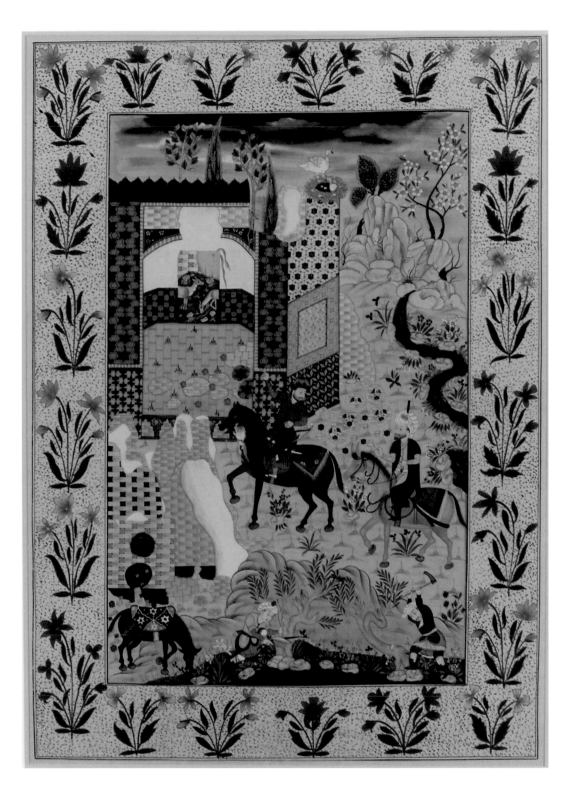

Unknown Artist • **INDIAN PRINT** • Silk Painting • 43" x 55" • Level One

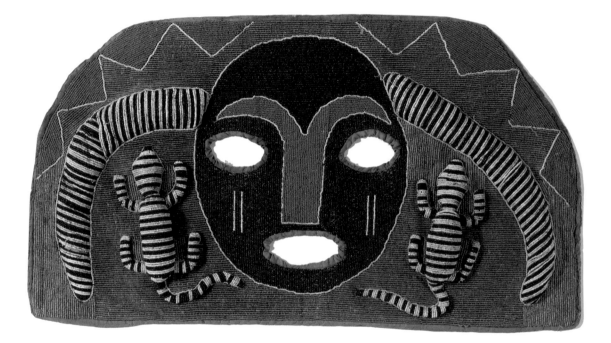

Unknown Artist • **UNTITLED (MASK)** • Beads/Textile • 27" x 37" • Level Two Lobby

This piece was a three-dimensional mask that fit over the head; the stitching was removed in order to better display the overall design and composition. The mask's bright vermillion color makes a striking contrast against the forest green ground.

Jean Lamerieux • **THE BEACH** • Oil on Linen • 53" x 65" • Level One

Jean Lamerieux lived in Paris and was sponsored by Peggy de Salle, a well known Detroit area art dealer and patron, to come to both Detroit and New York. He spent a portion of his time in Marrakesh, Morocco. This beach scene of a North African family sitting in the shade at the beach is evidence of Lamerieux's vibrant palette of glowing colors. Gift of Peggy deSalle.

George Vihos • **BLUE BUTTERFLY** • Oil, Stick on Paper • 75" x 145" • Level Two Entrance

George Vihos designed a unique method of framing his energetic line drawings. He sandwiched the large-scale drawings between two sheets of plexiglass and suctioned out the air. This is thought to be one of the largest drawings on one sheet of paper ever made. The designers and the art commission viewed ninety artists' work — this was one of the choices which has dominated the entrance of DRH for the past 20 years. A large monochromatic Vihos drawing adorns the back entrance at WSU school of medicine. Purchased by William Kessler and Associates for this site.

Robert Kidd • **UNTITLED** • Textile • 70" x 74" • Level One
This textile work was one of a series created by the artist in the 1970's. Robert Kidd was a distinguished fiber artist and the owner of the Robert Kidd Gallery in Birmingham, Michigan. He helped to end the segregation of textile as craft rather than fine art, and won major commissions for work at the Renaissance Center and the Dow Clinical Research Center in Houston.

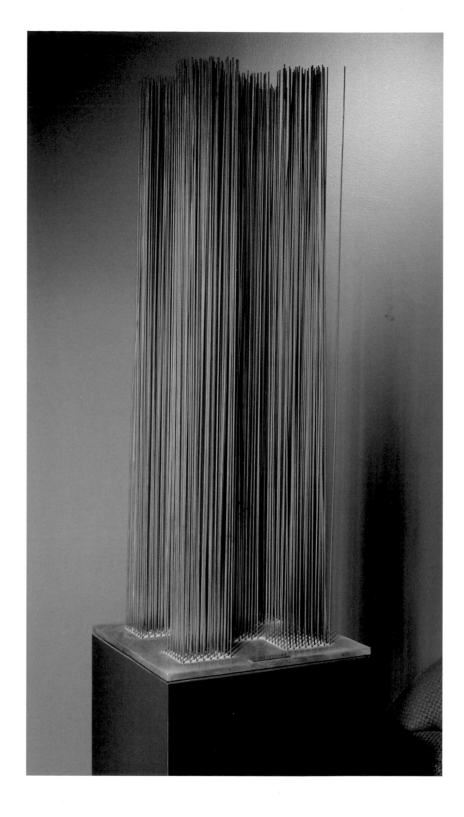

Harry Bertoia • **VERTICAL BRONZE SINGING RODS** • Bronze Sculpture • 16" x 16" x 60" • Level Three

Harry Bertoia is best known for his tonal or sounding sculptures, sometimes described as "metallic harps." A graduate of Cranbrook Art Academy, Bertoia taught graphics and metalsmithing there. This work was commissioned for the hospital meditation room by the Service League in 1977 and was moved to Administration once the new hospital was built. The singing rods sculpture served as an interdenominational altarpiece in the serene surroundings of the meditation room, which was designed by the Smith Hinchman Architectural firm. Donated through the grace and ambition of Mary Alice Keats, wife of the President of Wayne State University at the time.

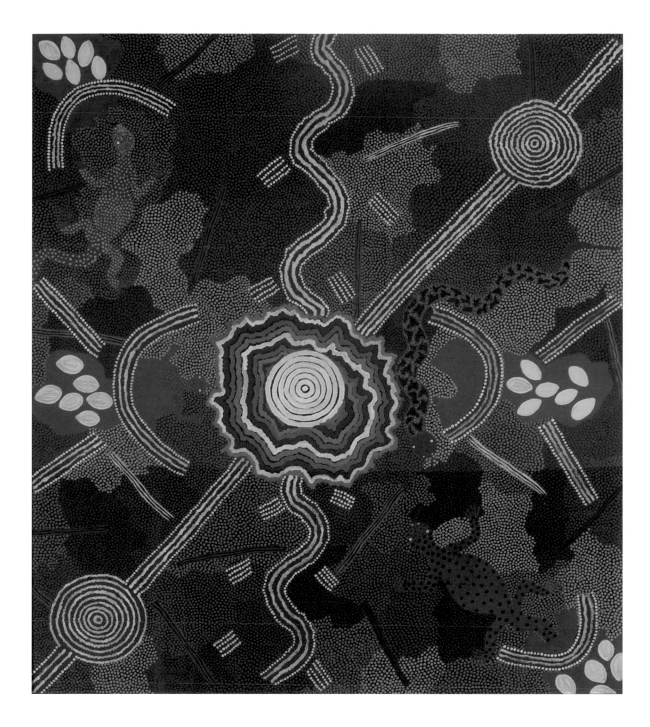

Jabaldjardl Cassidi • **DESERT DREAMS** • Acrylic • 51" x 56" • Level Two Corridor

The art and language of the Aboriginal people changes dramatically from region to region. Although the symbols used in this painting appear to be abstract, they follow a strictly coded graphic vocabulary. Snakes, lizards and small animals, traditional foods, are often the subjects of paintings. The practice of working with acrylic paint, which gives permanency to the transitory tradition of sand paintings and body decorations, lost or destroyed after the ceremonies, is relatively new. The Aborigine lived mostly in the desert and moved frequently, often leaving their possessions behind or "moving on." The work has become highly collectible, demanding high prices in New York and London art markets. The DRH collection includes two very interesting Aborigine works with gender-related messages, which were purchased in the Aborigine Museum in Adelaide, Australia.

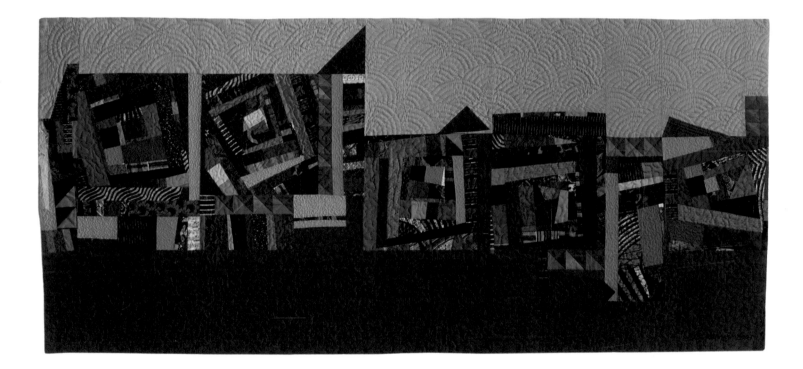

Carole Harris • **CITY RHYTHMS** • Quilt • 32" x 71" • ER Waiting

Commissioned for the new Emergency Room entrance, this beautiful contemporary quilt reflects the rhythm of the busy city with textures and patterns that portray the vibrant night cityscape across the Detroit River. Harris, a Detroit artist, is a nationally known quilt maker who has exhibited her work at the American Craft Museum in New York City and whose work has appeared in many books on contemporary quilts. "Quilts throughout history have had a special place in family values and society. Created in domestic settings, they are used for practical purposes and are decorative and historic." Carol Harris has gone beyond tradition in the design and construction of her quilts. This work was part of the emergency department's 2004 expansion project.

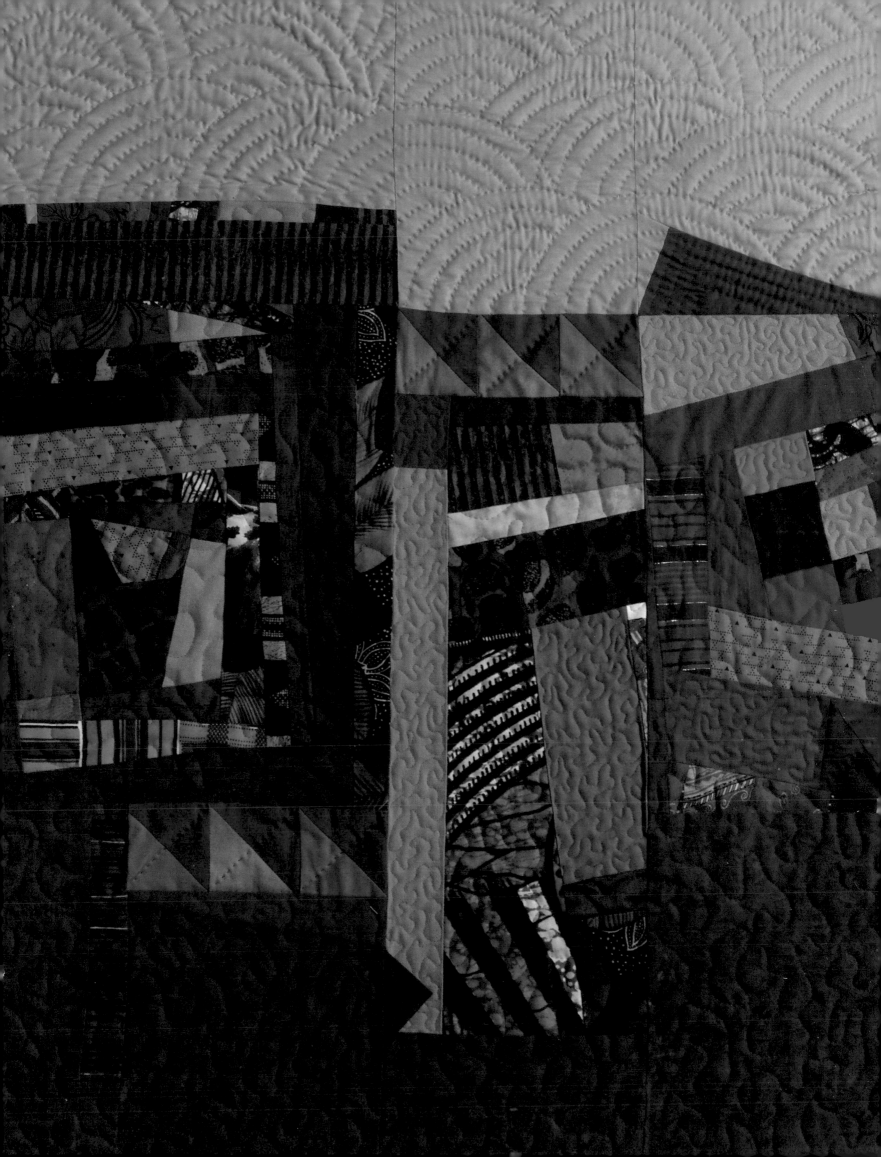

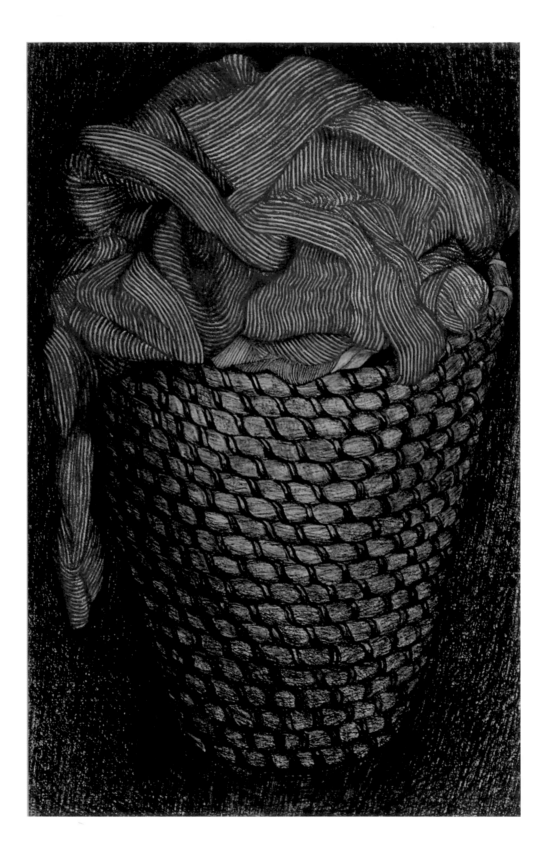

Sarah Cawkwell • **BLUE CORNUCOPIA** • Pastel • 41" x 26" • Level Two

Sarah Cawkwell is an English artist known for paintings and drawings of domestic scenes: shirts in laundry baskets, folded fabric and girls fixing their hair. Gift of Irene Walt, purchased on a trip to England.

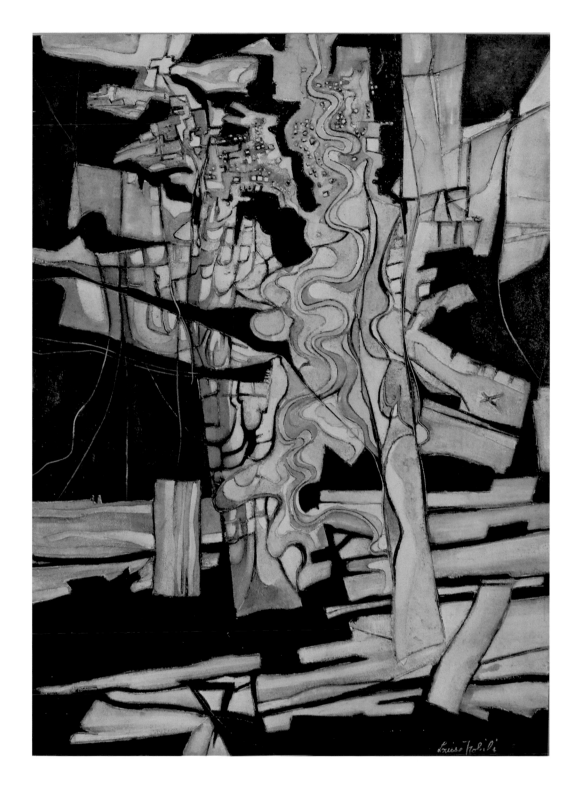

Louise Nobili · **ABSTRACT COMPOSITION** · Oil · 90" x 66" · Level One

A former faculty member of Wayne State University's painting department, Louise Nobili was an accomplished painter and teacher who created many Detroit public art commissions, including at the Wayne State Medical School. Nobili was awarded a first prize by the Detroit Institute of Arts Founders' Society and was a leading member of the Watercolor Society of Michigan. Her sabbaticals in Germany and Italy were a strong influence on her work. This work was inspired by a view from an airplane when flying over the city of Rome and is characteristic of the bold pioneering spirit of her work. Gift of the artist.

CLINTON-MACOMB PUBLIC LIBRARY

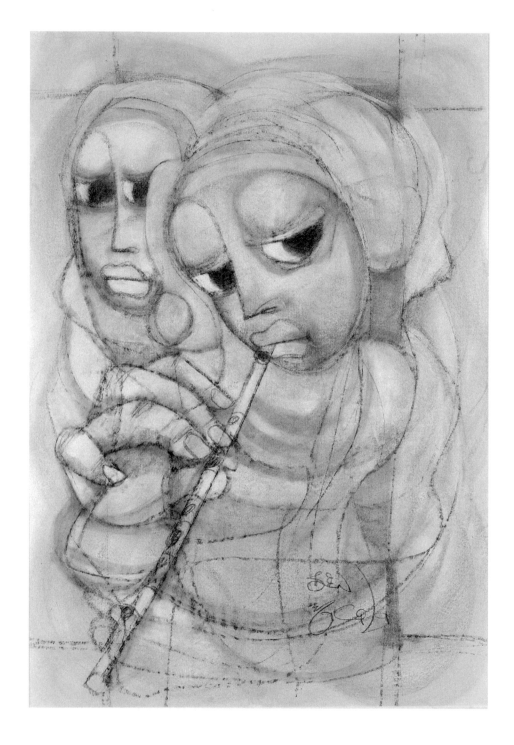

Ben • **UNTITLED** • Pastel on Paper • 42" x 30" • Third Floor Hospital

A well known South African artist who uses his first name only, Ben portrays most of his subjects playing one musical instrument or another. The penny whistle was often played by children in the townships; it was written about in "Cry, the Beloved Country," a book about the severity and anguish during the time of apartheid by Alan Paton. With simple line and monochrome palette, this painting shows a complex relationship between two people.

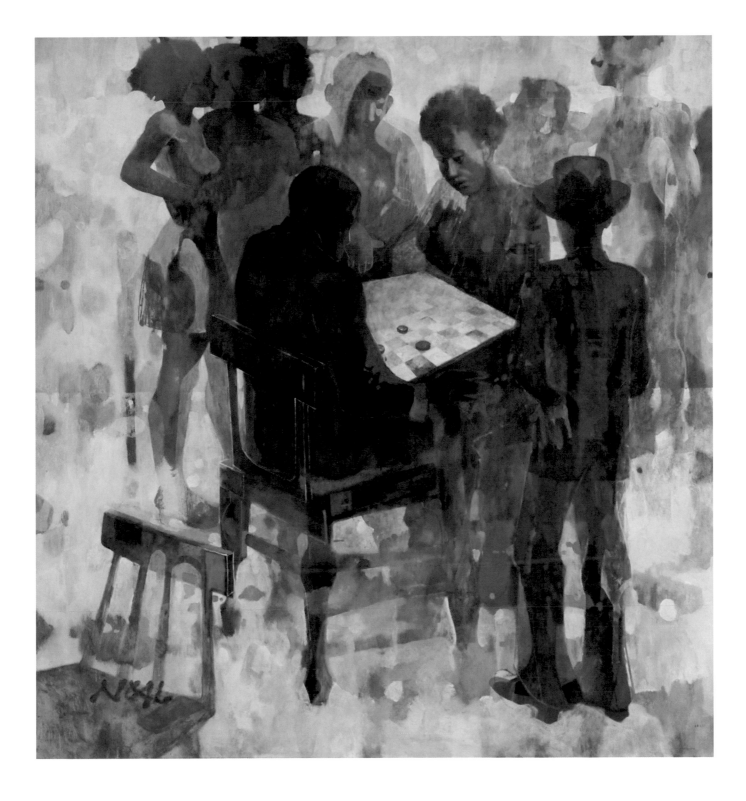

Harold Neal • **CHECQUERS** • Oil • 51" x 48" • Level Five

Harold Neal was a well known and important artist in the Detroit community. He painted scenes of Detroit and of local political figures. Neal was a member of the Gallery of 7, formed by Detroit artist Charles McGee in 1960. This work was one of the first major DRH public commissions. Underwritten by "New Detroit."

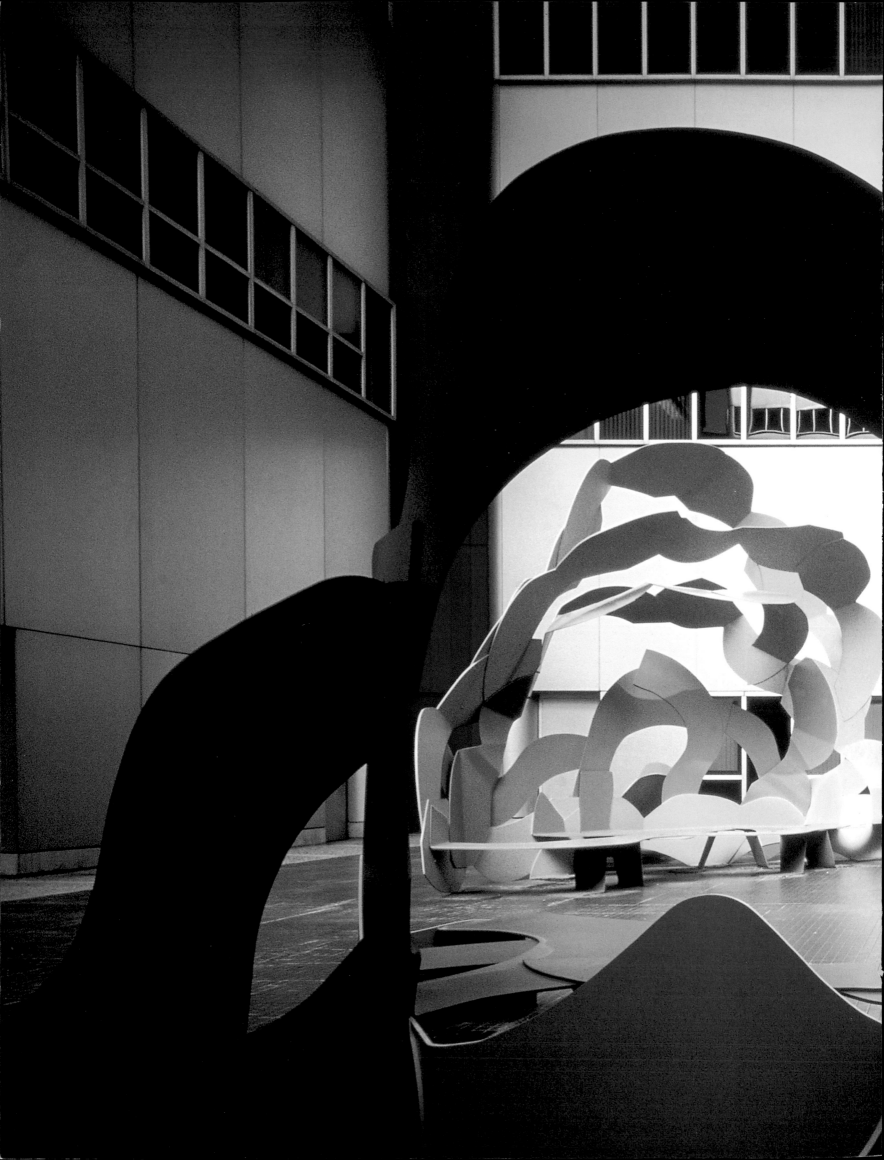

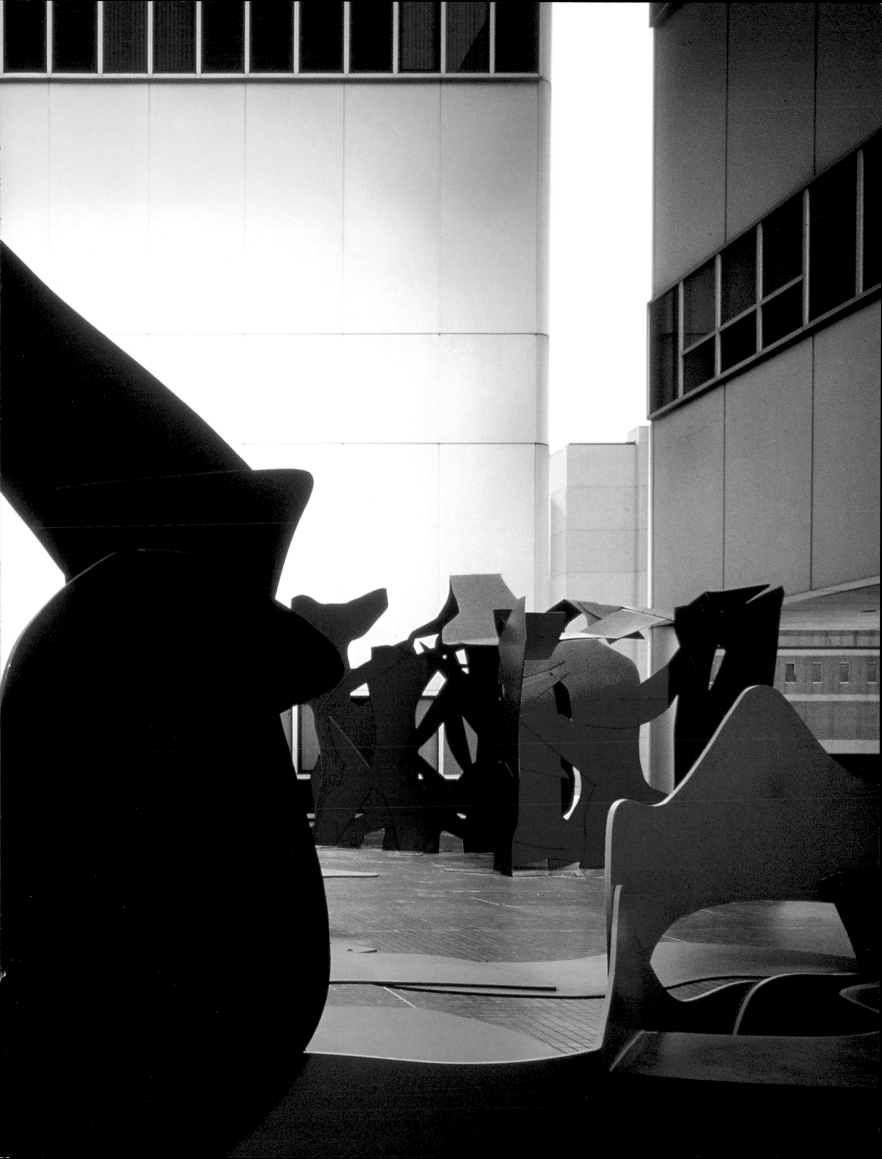

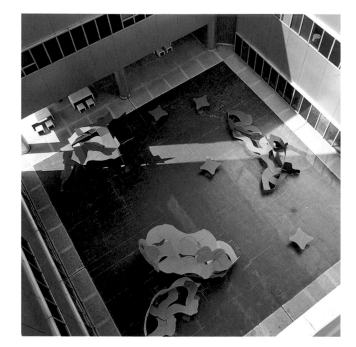 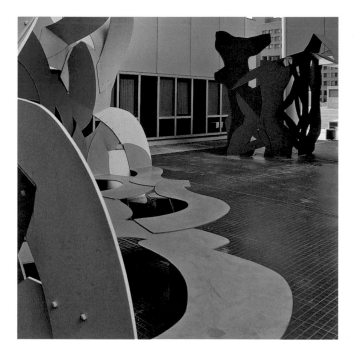

(Previous page, Above) George Sugarman · **FIELD SCULPTURE** · Metal · Cafetria Courtyard

In a main floor central courtyard accessible for outdoor dining, George Sugarman's "Field Sculpture" provides seating and shade, and promotes direct interaction. Formed from cut, bent, and bolted metal shapes in brilliant colors, the sculpture is an attraction for patients, staff, and visitors and serves as a backdrop to many outdoor musical concerts held at DRH. George Sugarman's environmental work is represented in major museums and public collections nationwide, including the Judicial Center in Baltimore, Maryland and the Federal Building in Toledo, Ohio, and in other public spaces that provide scope for his soaring use of space and color. Funded by the City of Detroit Building Authority in 1979.

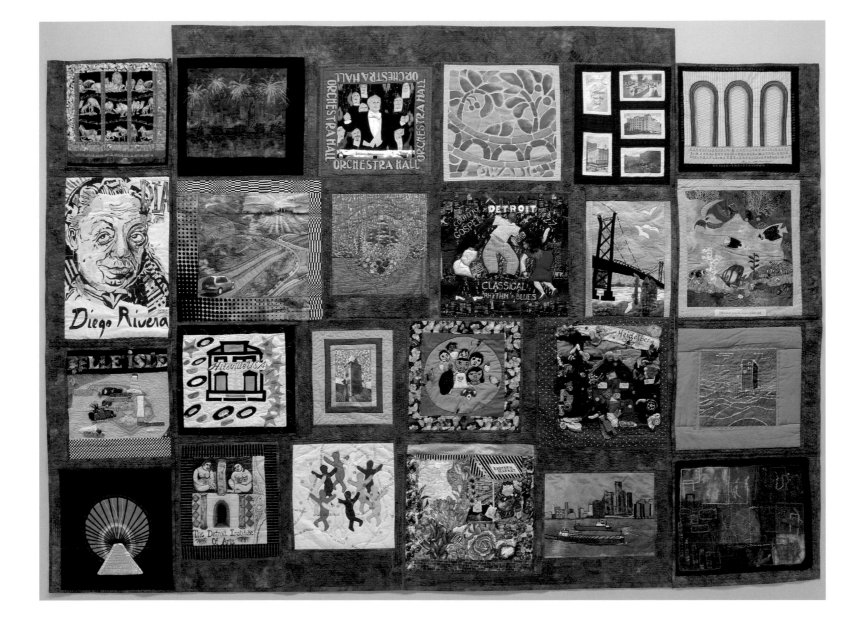

Various Artists • **WEAVE US TOGETHER** • Quilt • 91" x 148" • UHC Lobby

The "Weave Us Together" quilt was conceived by the American Sewing Expo's sewing and fiber artists, and Expo presenter, Jane Pray, as a tribute to the City of Detroit. These metro Detroit area artists felt it was their collective responsibility to preserve the most positive aspects of the City of Detroit in the form of an art quilt. This beautiful quilt was created by twenty-three different artists — Barbara Altweger, Mary Bajcz, Boisali Biswaf, Justine Burnell, Debbie Cooper, Mary Gentry, Donna Hamilton, Sue Holdaway-Heys, Elaine Yancy Hollis, Sung Im, Pat Ingersol, Betty Ives, Urban Jupena, Andrea Lozano, Wanda Nash, Loretta Oliver, Janet Pray, Meena Schaldenbrand, Claire Teagan, Pat Thompson, Saundra Weed, Beverly White and Kay Whittington. Donated to DRH in 2004.

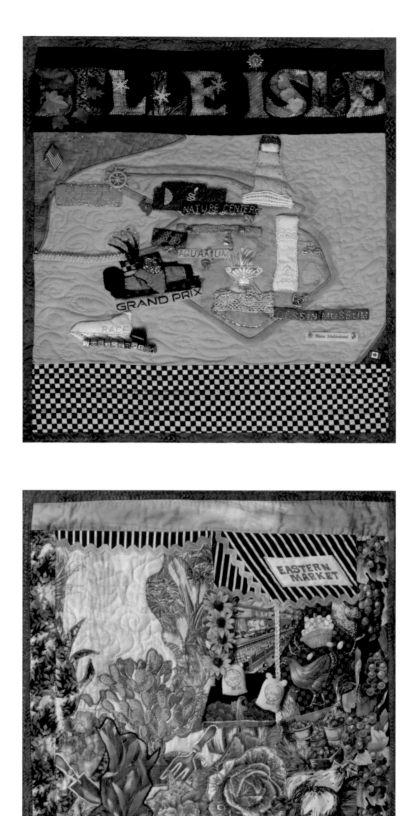

Various Artists • **WEAVE US TOGETHER** (Details) • Quilt • UHC Lobby

(Top) Meena Shaldenbrand, *Belle Isle*; (Bottom) Betty Ives, *Eastern Market*

(Opposite, Top) Boisali Biswaf, *Freedom Festival*; (Opposite, Bottom) Elaine Hollis, *Heidelberg Project*

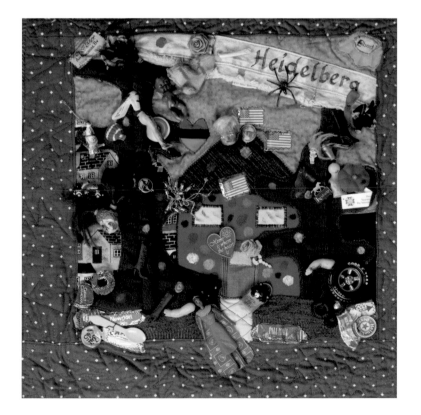

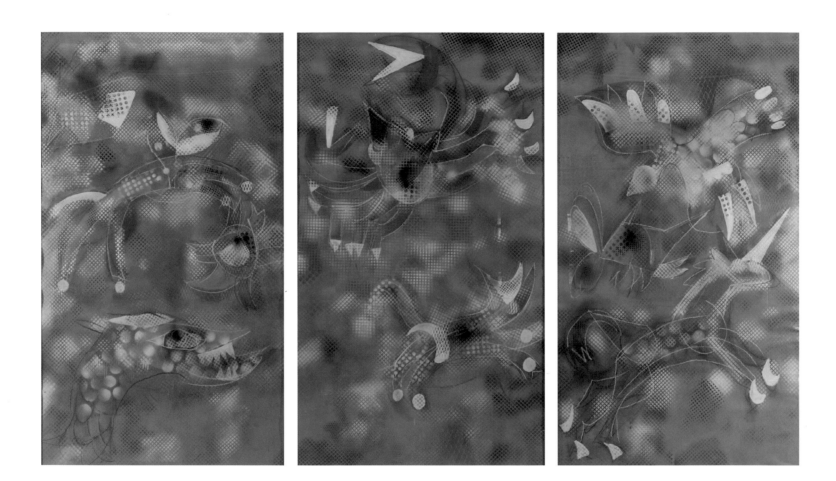

Gerome Kamrowski · **VOYAGE** · Acrylic on Paper · 49" x 60" · Level Two Lobby

During the 1930's and 40's in New York, Gerome Kamrowski was at the forefront of development of American Surrealism and Abstract Expressionism. He left New York to head the painting department of the University of Michigan in 1948, but continued to work and exhibit internationally from his home in Ann Arbor until his death in 2004. His work is represented in most major museums and in many public and private collections. This work, whose imagery was influenced by ancient maps of the heavens and mythological zodiac figures, served as a maquette for Kamrowski's mosaic tile installation for the Detroit People Mover's Joe Louis Station. The paper maquette was sent to Italy to a mosaic glass studio, where it was translated into two large mosaic walls for the station. "Voyage" was commissioned by the Detroit People Mover Art Commission.

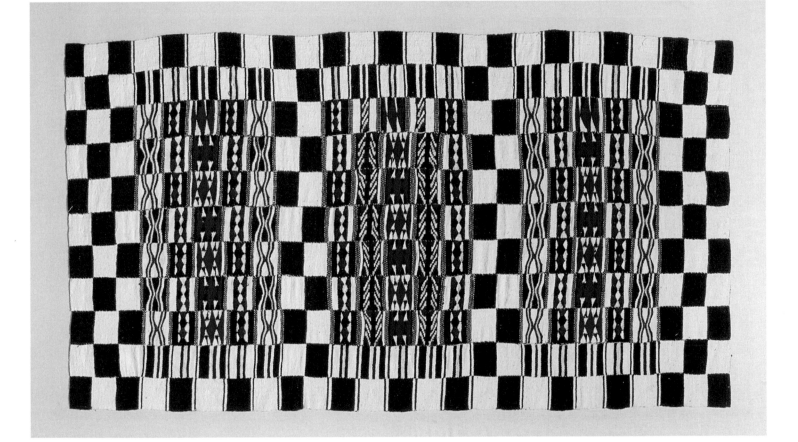

Unknown Artists · **KOSSO KALANS FROM MALI** · Textile · 54" x 88" · Main Corridor

Kosso Kalans, which are cotton cloth blankets, are woven by the men on primitive small looms set up on hot, dusty African city streets. The weaver sits peacefully, usually on the sidewalk, pedaling and rhythmically moving his hands sideways inside the make-shift cage-like frame of the loom. Four colors are used in the looms, white, black, yellow, and red. During the cold months, the owners of these blankets wrap themselves from head to foot in shroud-like fashion, and in summer the blankets are used as protection from mosquitoes. Often, the owners are buried in these cloths.

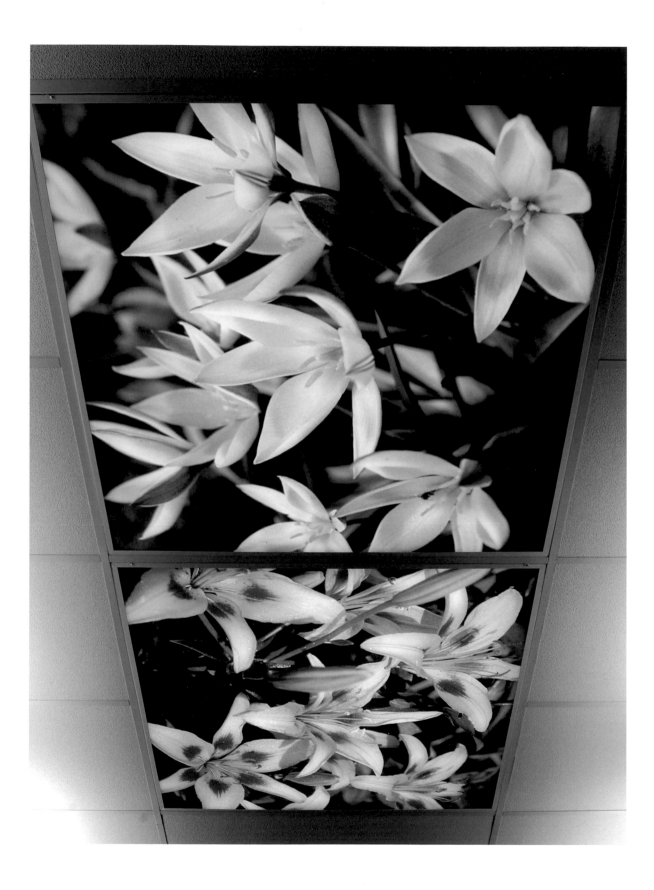

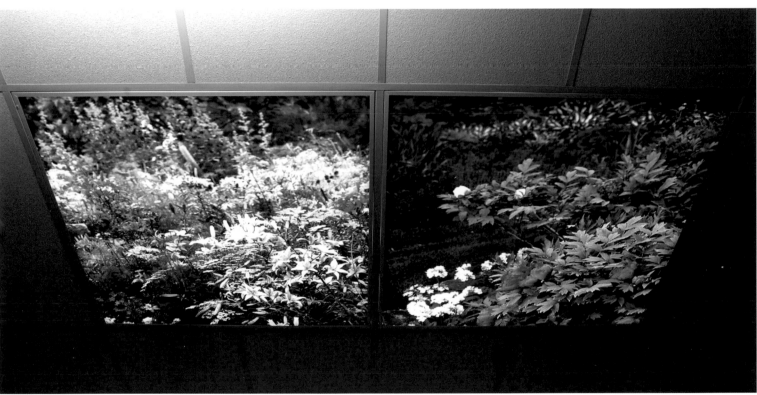

Balthazar Korab • **CEILING PANELS** • Color Transparencies • 48" x 48" (ea.) • ER Waiting

These colorful garden scenes, in the form of back-lit photo transparencies incorporated into the lighting fixtures, are intended to transport patients to a peaceful, more beautiful place while they wait in the ER and to brighten the environment as patients are wheeled through the corridors on their way to surgery. DRH was one of the first hospitals to use photo murals in ceiling panels and has advised several other hospitals on the technical aspects of installing ceiling photo panels.

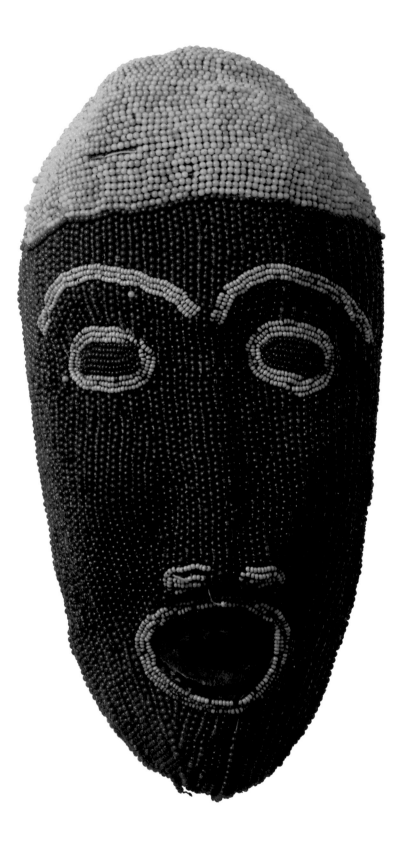

Unknown Artist • **UNTITLED (MASK)** • Beads/Textile • 25" x 17" x 6" • Level Two Lobby

This mask come from North Africa, where beadwork is often used for ceremonial occasions. Early explorers brought beads to be exchanged for gold and ivory or land; there was a time in Africa when beads were treasured above human life.

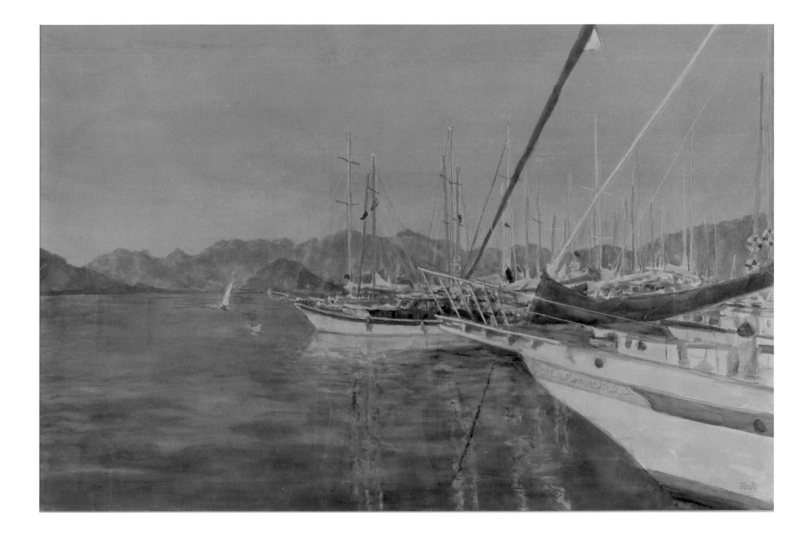

Marjorie Hecht Simon • **TURKISH SEA** • Watercolor • 40" x 60" • Level One

A Detroit artist since 1947, Marjorie Hecht Simon trained at the School of the Art Institute of Chicago. She is best known for her still life and landscape paintings, with many of her paintings, like "Turkish Sea," inspired by her extensive world travel. Hecht, a neighbor of Mrs. Walt, often provided donations of works to DRH over the years; over sixty of her watercolors are part of the DRH permanent collection. Hecht has created murals in the Psychiatric ward and the Pediatric Radiation Oncology Department at Karmanos Cancer Center, ten of her paintings hang in the Bariatrics Area of Henry Ford Hospital, and she has participated in the rental program at the Flint Institute of Art. The demands of freshness and immediacy in the watercolor medium are evident in her work whether large or small in scale.

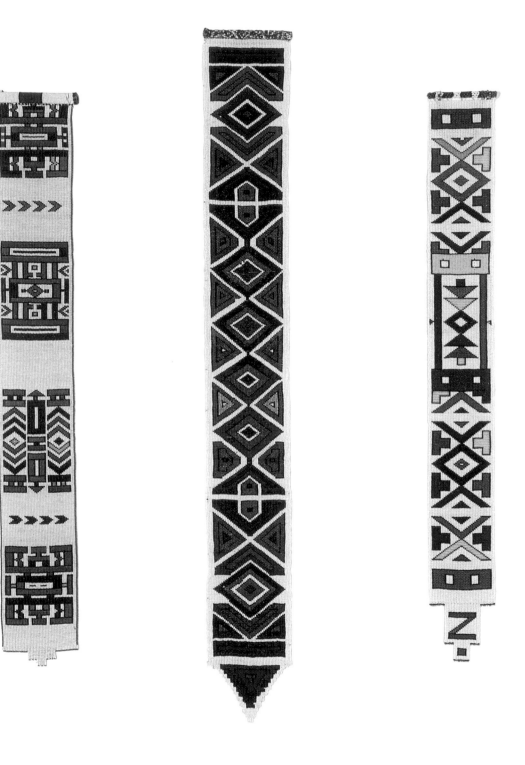

Unknown Artist · **NDEBELE HEADDRESSES** · Beaded Materials · Main Lobby

The South Ndebele are one of Southern Africa's most creative people. Their skills range from mural paintings to beaded works. The dress of Ndebele women becomes more elaborate once she has married. As a sign of respect for her husband, an Ndebele woman keeps her head covered. Headdresses range from simple bands of beads like these to very elaborate tiaras.

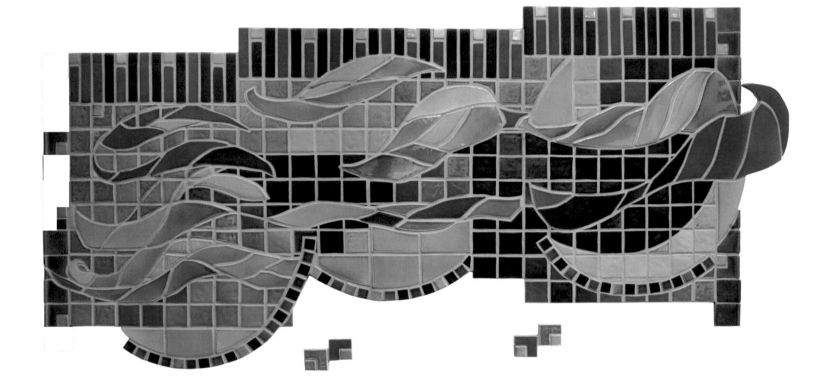

Pewabic Pottery (Designer Geniever Sylvia) • **UNTITLED** • Ceramic Tile • 60" x 125" • ER Waiting

Integrated into this contemporary mural are the traditional glazes for which Pewabic Pottery is best known. Pewabic Pottery was founded in 1903 by Mary Chase Perry (later Mary Chase Perry Stratton) and her partner, Horace Caulkins (developer of the Revelation Kiln), at the height of the Arts & Crafts movement in America. Today Pewabic Pottery is an institution with education, exhibition, museum and design and fabrication programs. The pottery fabricates heirloom quality architectural tiles for public and private installations. Through its historic exhibits, it tells the story of the pottery's role in the history of Detroit, the growth of the Arts & Crafts movement in America and the development of ceramic art. Pewabic Pottery was recently recognized by the National Trust for Historic Preservation as a "Historic Artists' Homes and Studios" site. The mural is framed with green tiles donated by the Stroh Brewery, and was included in the emergency department's 2004 expansion project.

Unknown Artist • **UNTITLED** • Oil • 49" x 60" • Level One

This hard edge abstraction, a gift to the Wayne State University art collection, was painted about 1923. Its bold graphic quality serves as a way-finding tool. Gift of Wayne State University.

Lester Johnson • **ABSTRACT COMPOSITION** • Oil • 50" x 50" • Level Two Corridor

Lester Johnson is a native Detroiter who earned both B.F.A .and M.F.A. degrees from the University of Michigan. He is currently a Professor of Drawing and Painting at the College for Creative Studies. When proposing this painting twenty-five years ago, Johnson was intent on creating a color range to compliment architect William Kessler's contemporary uses of color in the hospital building. This work, reminiscent of the color-study work of the artist Joseph Albers, was commissioned for the opening of the University Health Center by William Kessler and Associates.

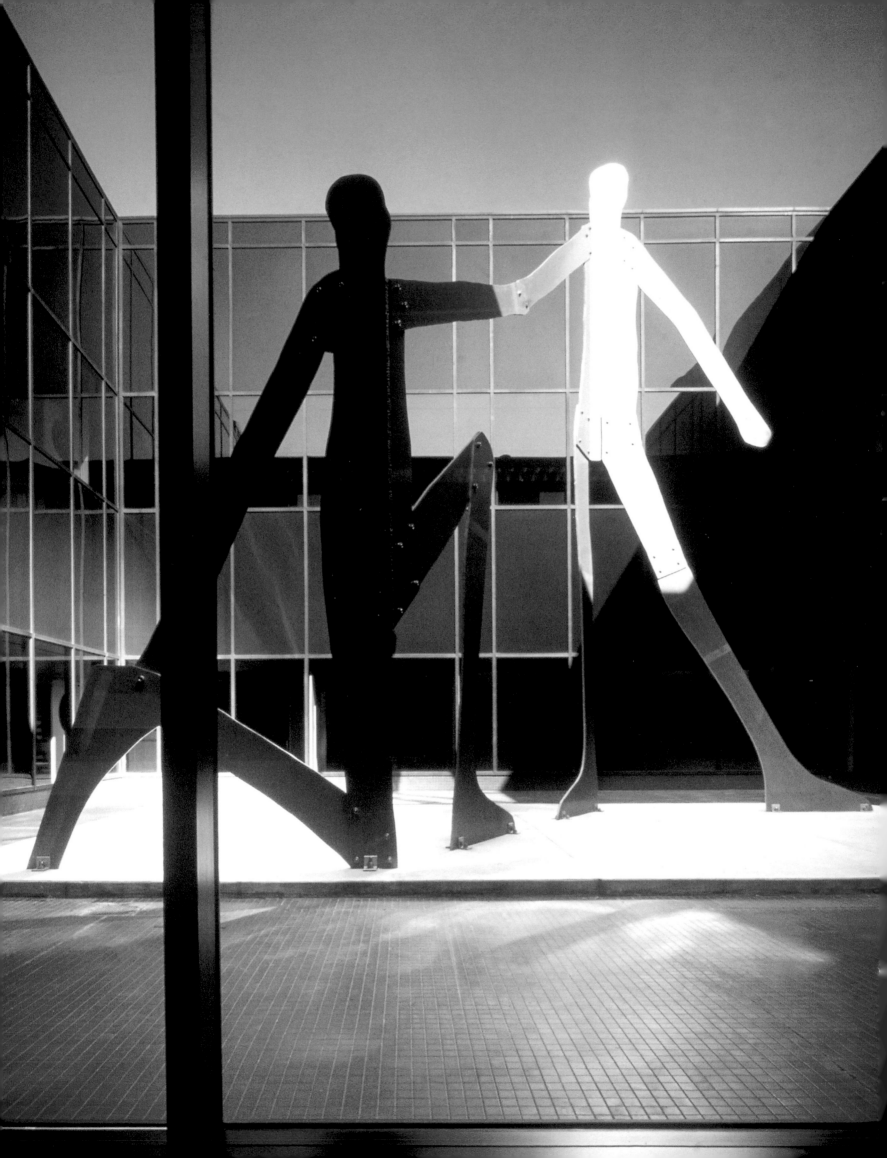

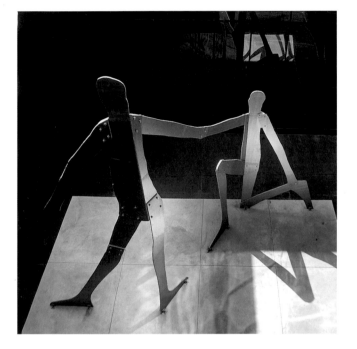
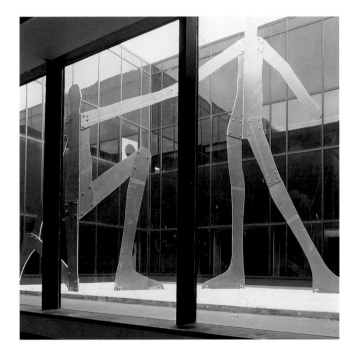

William King • **HELP** • Aluminum • Four Story Hospital Courtyard

Fabricated from one inch thick aluminum, "Help" shows two figures, one extending a hand to the other. Each piece is twenty feet long by six feet wide. The standing figure rises thirty-two feet in a third floor courtyard of the hospital. "Help" was commissioned to honor Carl Levin, President of the Detroit City Council from 1971 to 1978, and was funded by the Friends of Carl Levin in 1979.

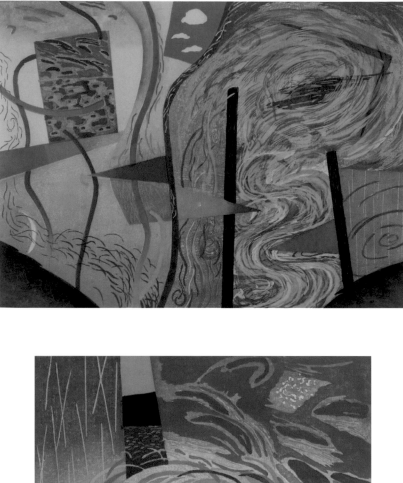

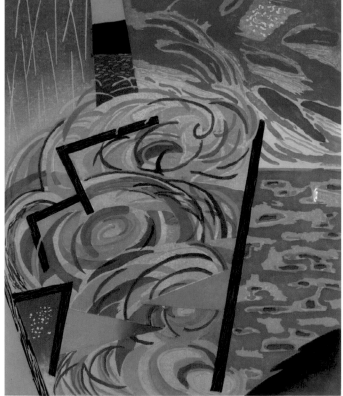

(Top) Yoriko Cronin • **3 CLOUDS & KITE** • Woodcut • 36" x 32" • Level Three

(Bottom) Yoriko Cronin • **HOMEWARD BOUND X** • Woodcut • 37" x 32" • Level Three

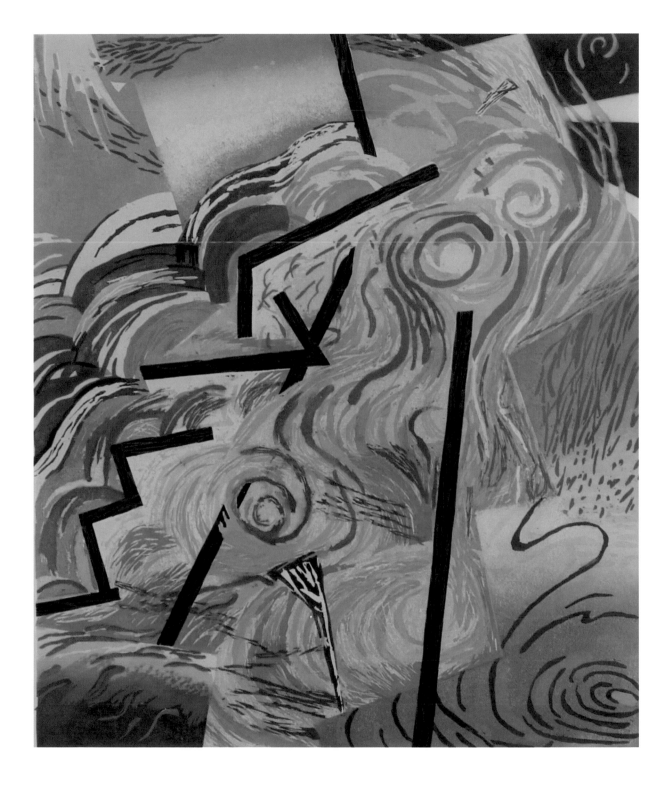

Yoriko Cronin • **HOMEWARD BOUND III** • Woodcut • 39" x 34" • Level Three

Cronin, a Japanese artist trained as a printmaker at The University of Michigan and Wayne State University, uses a woodblock printing method developed over two hundred years ago in Japan. With her interest in keeping the traditional Japanese woodblock printing method alive for future generations, Cronin's technique also provides a textured wood grain surface of luminous layers of color on Japanese paper. Her use of muted colors speaks of a quiet time in the old country. These are some of only a few wood block prints in the DRH collection; they add warmth and a calm vibrancy to the collection.

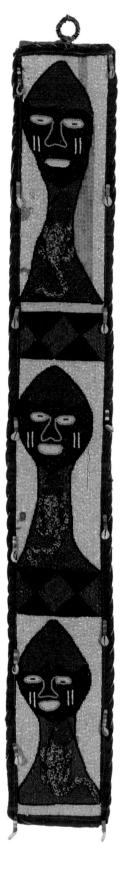

Unknown Artist • **YORUBA BELT** • Beads/Textile • 55" x 16" • Level Two Corridor

Beads were signs of wealth and status. Many Yoruba sacred and secular objects were embellished with elaborate images and symbolic designs created with small glass beads. The sashes are symbols of an owner's spiritual position and are worn in public ceremonies. Beads were used for exchange of land and resources. The transparent beads were imported from Austria at the turn of the last century.

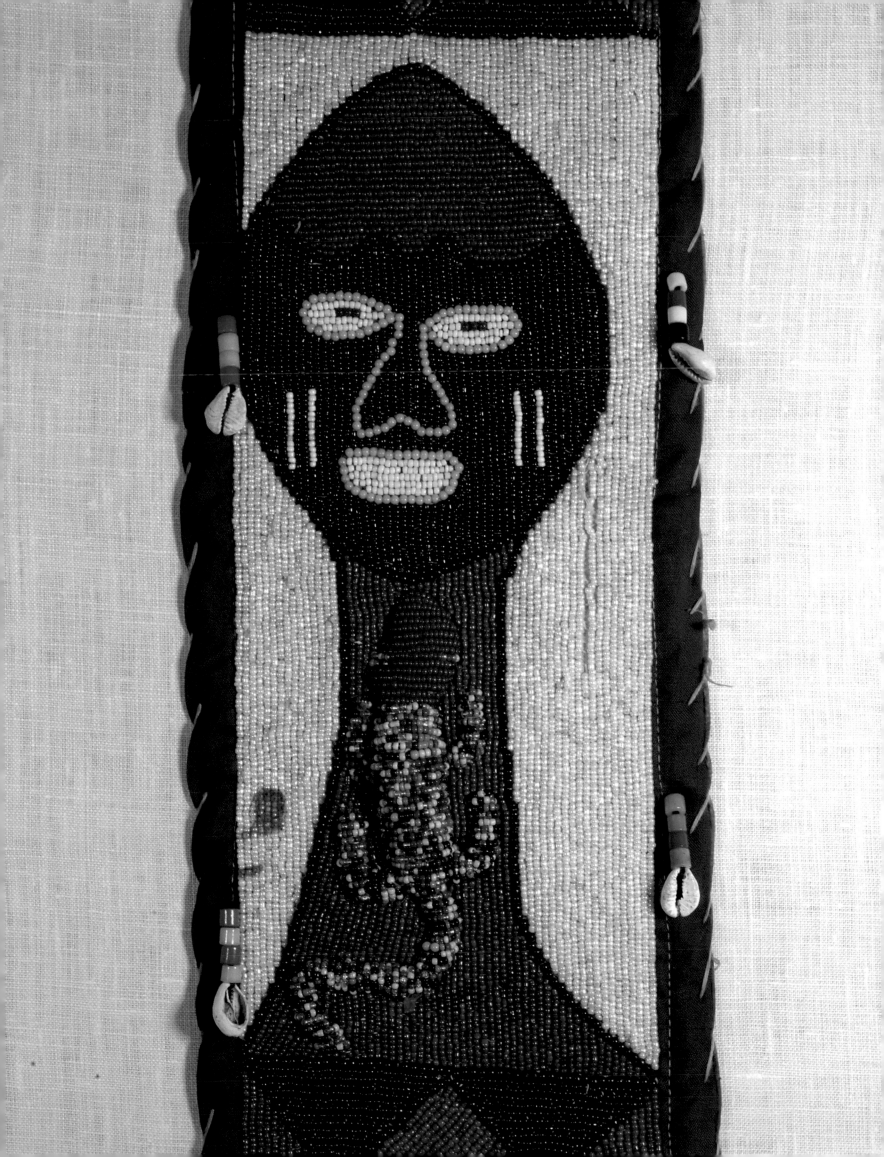

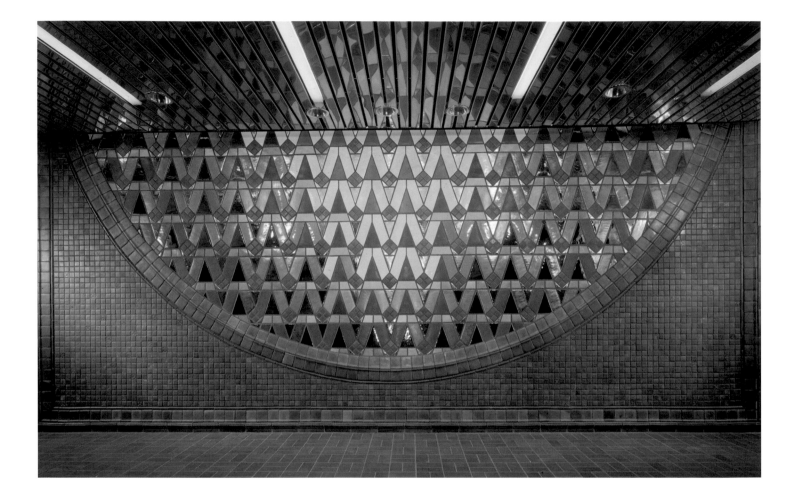

Diana Pancioli · **THE ARC** · Ceramic Tile · 10.6' x 25' · UHC Entrance

Diana Pancioli was born in Detroit and received a B.F.A. (cum laude) from Wayne State University, and an M.F.A. from New York State College of Ceramics. She is on the faculty at Eastern Michigan University. This ceramic tile mural, designed and created by Pancioli at EMU in Ypsilanti, incorporates original handmade tile and historic Pewabic tile, previously commissioned by the Stroh Brewery from Pewabic Pottery in 1955. The lower green tile field consists of the histoic Pewabic tile, while the upper tiles in the arch shape were newly created for the project by Ms. Pancioli. Completed in 1995, "The Arc" commemorates the 15th anniversary of Detroit Receiving Hospital and University Health Center. The green tile, donated by Peter Stroh and Stroh Brewery to the Detroit People Mover, was a generous donation to DRH from the Detroit People Mover. The mural was funded by Friends of Detroit Receiving Hospital, including donors whose initials are represented in embossed tiles within the design; and by the Detroit Receiving Hospital Board led by Philip Meath and Ed Thomas.

Lynn Galbreath • **ISLE ROYALE** • Oil on Wood • 48" x 118" • ER Waiting

Lynn Galbreath received a B.S. from Western Michigan University an M.F.A. from Wayne State University. She is a recipient of numerous awards, including Creative Artist Grant, 1998; Michigan Individual Artists Grant, 1991; IWCA Outstanding Video Award 1990. This triptych is a welcome focal point in the waiting area, and was included in the 2004 Emergency Room expansion project.

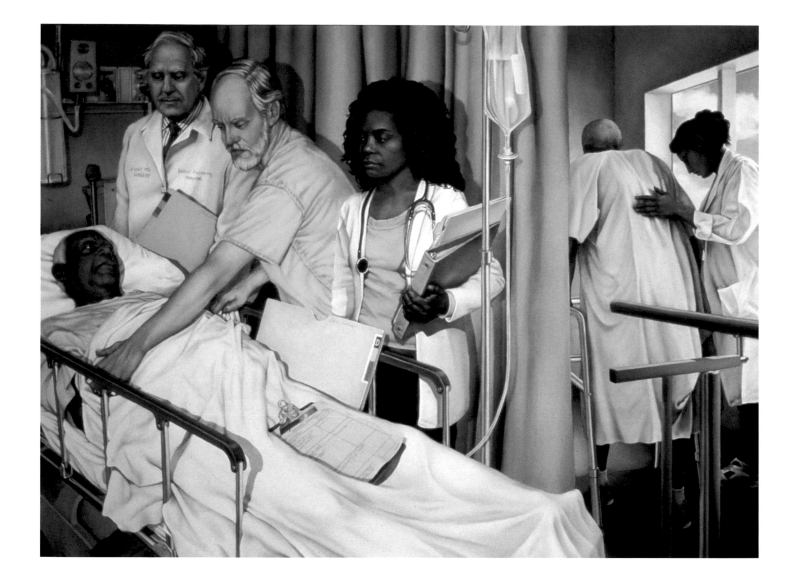

Robert Schefman • **GIVING/RECEIVING** • Oil on Linen • 54" x 70" • Main Lobby

Robert Schefman writes: "Receiving Hospital is such a dynamic place. A facility for emergency care, rehabilitation, research and teaching. I spent a couple of weeks walking around the hospital in preparation for this painting, and was most impressed by the people. I found that this facility went beyond medical treatment, it dispensed medical care. That was the intent of Giving/Receiving." Four employees of DRH, including the late Dr. Alexander Walt, Chairman of WSU surgery department, served as models for the painting. It is installed near the Trauma Unit in honor of Dr. Walt. Funded by the Michigan Council for the Arts and Cultural Affairs.

Charles McGee • **TIME MUTATIONS** • Sculpture • 36" x 144" • ER Waiting

A driving force in Detroit's art community, McGee headed the painting department at Eastern Michigan University and founded the Charles McGee School for Art. His work has been exhibited at the Detroit Institute of Arts, Howard University and the Dennos Museum. His public works include the Broadway Station of the Detroit People Mover, Bishop International Airport in Flint, Henry Ford Hospital and Beaumont Hospital. "The belief that all matter exists and operates equally in the service of nature is the basic tenet shaping the content of my work." This piece was the first of McGee's hospital installations, and was included in the emergency department's 2004 expansion project.

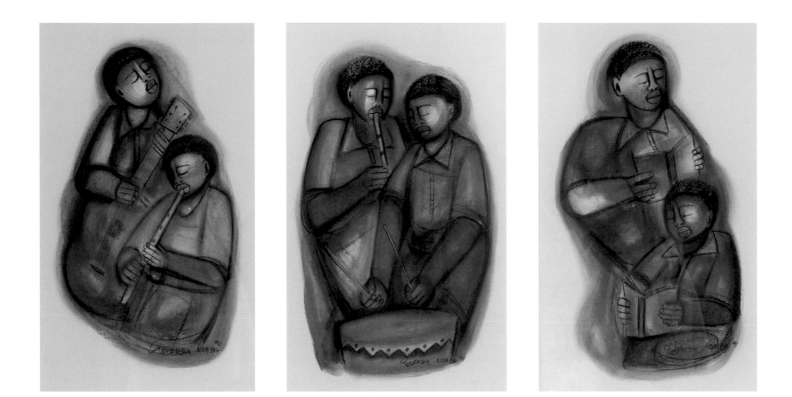

Gedfrey Ndaba • **SINGING FIGURES** • Print Series • 30" x 21" (ea. above), 30" x 38" (opposite) • Level One

Born in Johannesburg, South Africa, Ndaba went to the Ndaleni Art School in Natal, where he studied and became an art teacher. His work, which concentrates on depictions of his fellow human beings, has been exhibited in galleries throughout Africa, Israel, Australia, Europe and the United States. These works show Africans playing guitars, drums, and the penny whistle. Purchased in Johannesburg by Mrs. Walt.

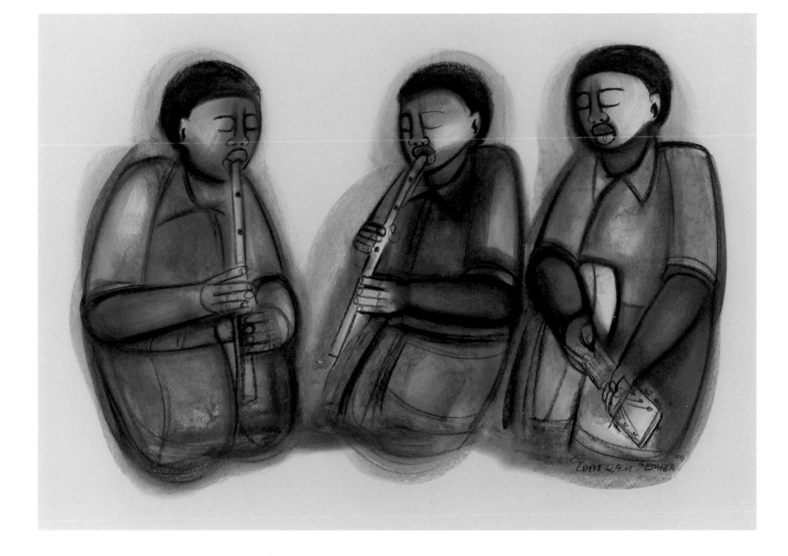

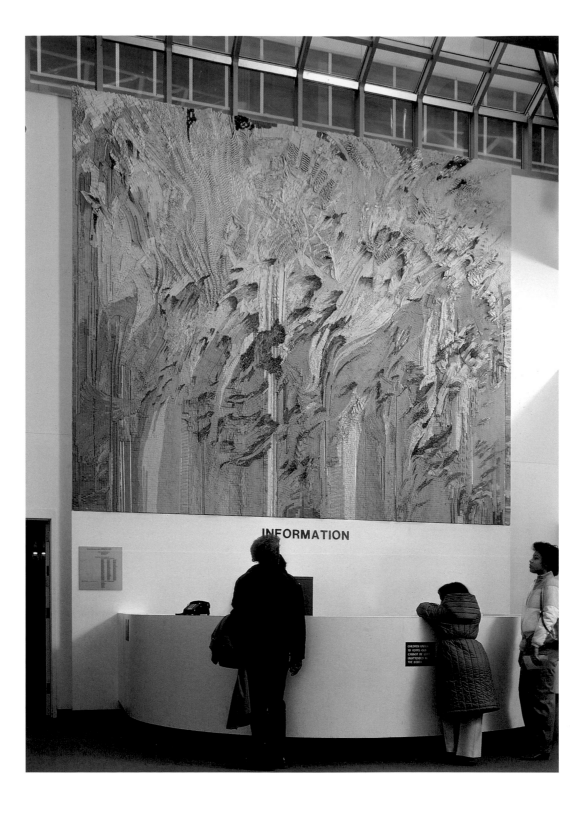

Glen Michaels • **WINDSCAPE** • Mixed Media • 14' x 17' • DRH Lobby

Glen Michaels' creations in stone, tile and other objects create three-dimensional compositions that often seem closely tied to the natural world in their evocation of water currents, wind over wheat fields, or exposed rock strata. His large assemblages and commissions are included in the collections of Rockefeller Center, the Monetary Fund/World Bank in Washington, D.C., and many other major public and private collections. Michaels holds a degree in music from Yale University, a B.A. from the University of Washington, and an M.F.A. from Cranbrook Academy of Art. His massive bas-relief of gray and white shaded mosaic tiles and chrome plated metal incorporates interweaving fan shapes based on the Bargello stitch to give the illusion that every tile is a brush stroke. The assemblage was installed in ten sections on a steel frame above the reception desk of the hospital. This work was funded by the Medical Alumni of "Old" Receiving Hospital Art Commission in 1979.

Unknown Artists • **NDEBELE PAINTINGS** • Acrylic on Paper • 23" x 29" • Main Corridor

The Ndebele tribe have lived in South Africa for over four hundred years. The techniques and designs of geometric motifs, diverse in color and composition, have been handed down from mother to daughter. Recently, modern icons have been incorporated into the designs; indicative of the Ndebele's adaptability to change, on the one hand and of their determination to maintain tradition on the other. The subject matter of Ndebele art, for the most part, relates to basic things that the people see around them; the home motif is their most recognizable image.

Janet Christiansen · **UNTITLED** · Oil · 50" x 58" · Level One

Christiansen is a realist still life painter and sculptor who trained as a glassmaker in San Francisco and taught glass at the presti-gious Pilchuck Glass School. Her work is included in both private and public collections in California and Michigan. This painting, which carries the same precision and love of color that are evident in her glass installations, was purchased directly from the artist.

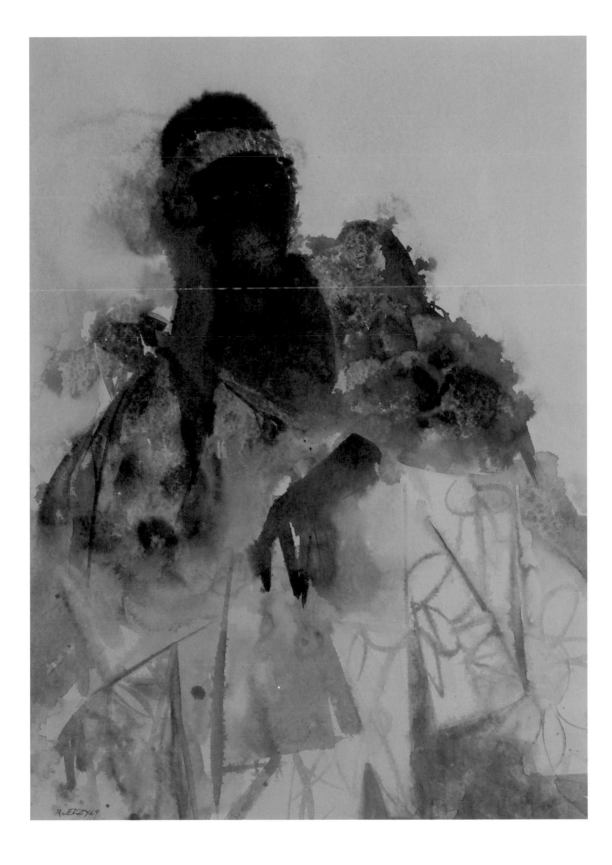

Richard Jerzey • **SEATED WOMAN** • Watercolor • 36" x 28" • Level Four

Richard Jerzey was an major figure in Detroit's art community and was the head of painting for many years at the College for Creative Studies. His work had a great sense of color and style. This painting won first prize in the College for Creative Studies Annual Exhibition and was donated to DRH by the artist.

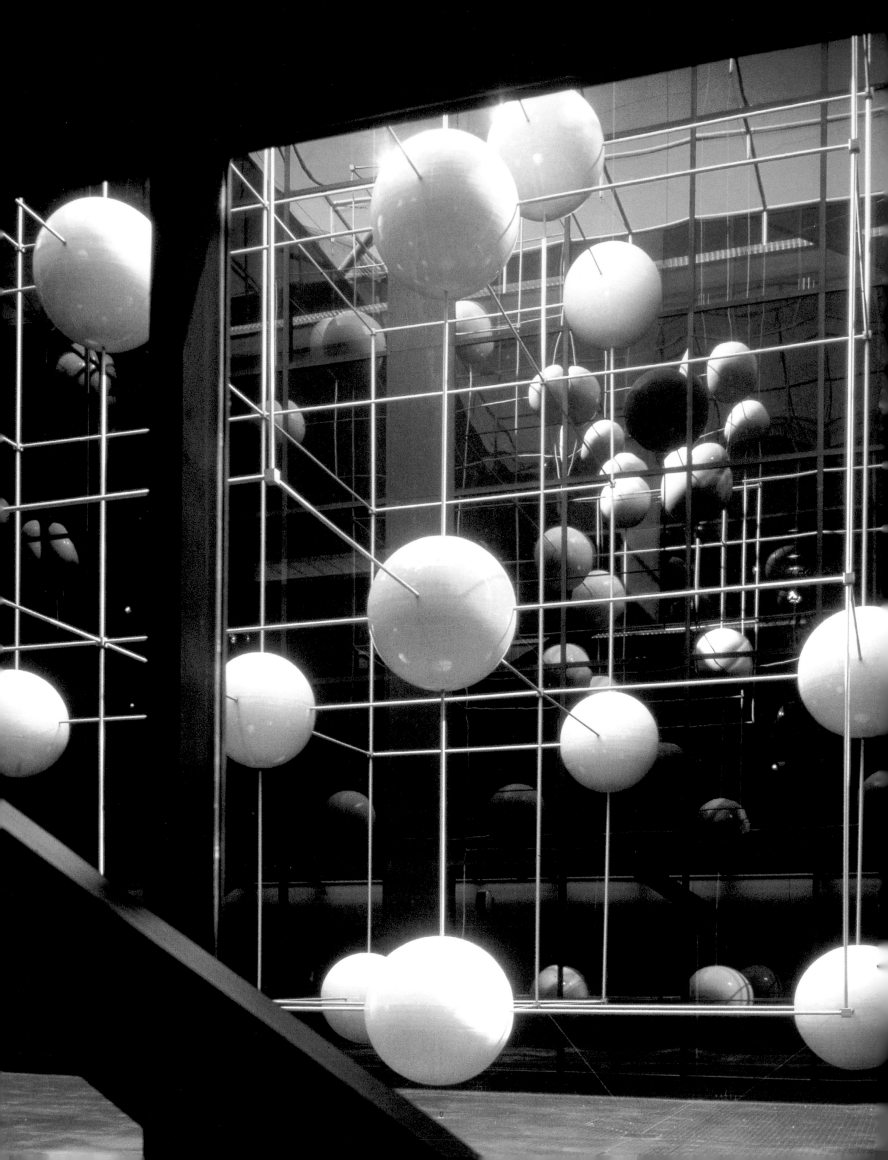

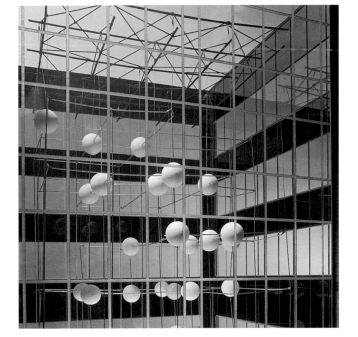
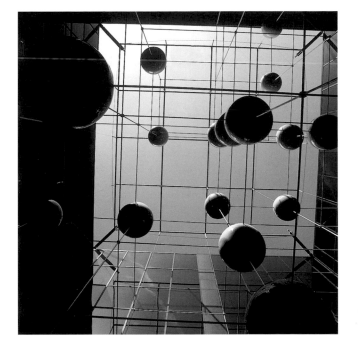

Joseph Kennebrew IV • **111/4K** • Spun Aluminum Spheres • Four Story UHC Courtyard

Inspired by the elements of molecular structure and consisting of twenty-four giant aluminum spheres, "111/4K" is supported by a grid that fills a four-story courtyard in the health center. Each sphere is painted white except one, which is yellow. Kennebrew is nationally known for another environmental work — Fish Ladder" in Grand Rapids — which helps spawning salmon to climb up-stream. The DRH sculpture was commissioned to honor the late George E. Gullen, Jr., President of Wayne State Unviersity, 1971-1978, and was funded by the Friends of George E. Gullen, Jr.

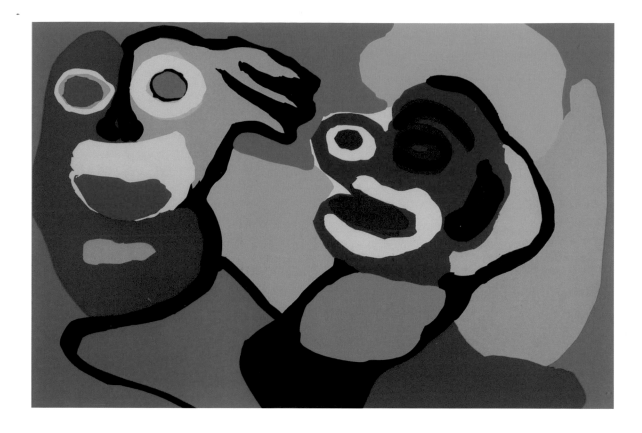

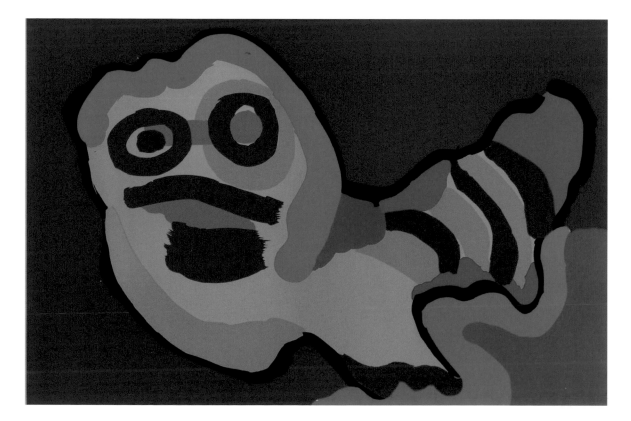

Karel Appel • **SUNSHINE PEOPLE** • Print Series • 32" x 44" (ea.) • Level Two Lobby

Karel Appel was a Dutch painter whose early work was influenced by Picasso, Matisse, and Dubuffet. He worked freely with color and developed a spontaneous and expressive style. Appel's dynamic and colorful work was influential for American and European artists; he is considered one of the founders of the COBRA group of European Expressionists. Donation from Wayne State University Collection.

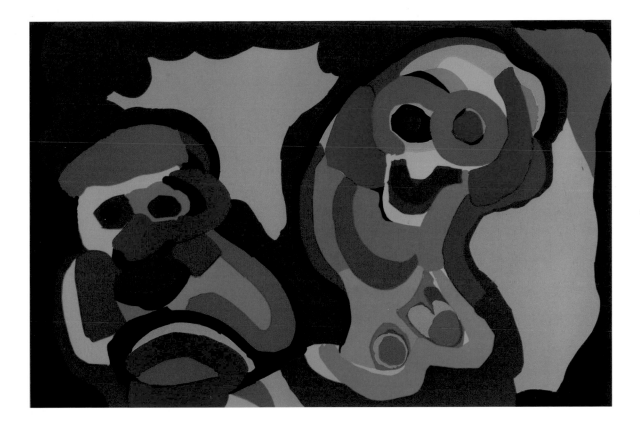

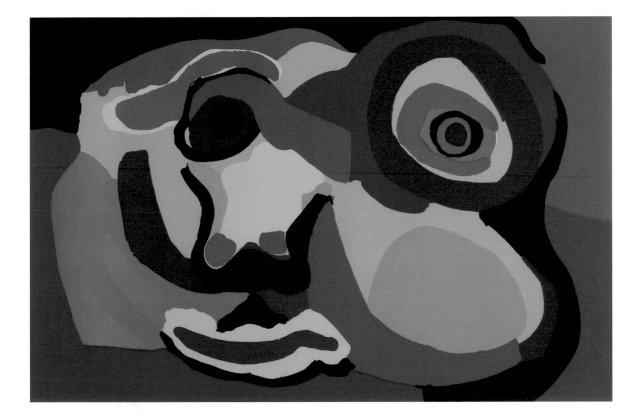

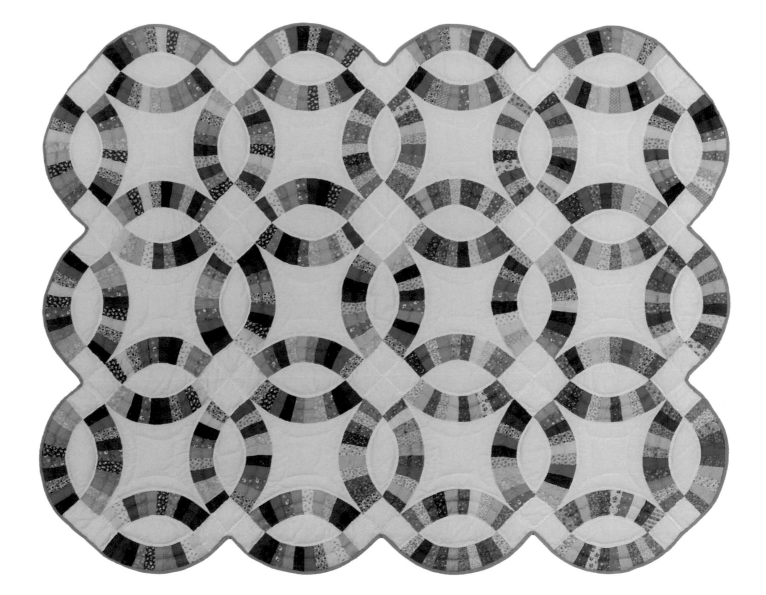

Unknown Artist · **ANTIQUE QUILT** · 49" x 60" · Level Five Rosa Parks Geriatrics Center

This quilt is in the "Wedding Ring" pattern. It was probably intended for use on a child's bed. Donated by Mr. & Mrs. Rich Oppenheim

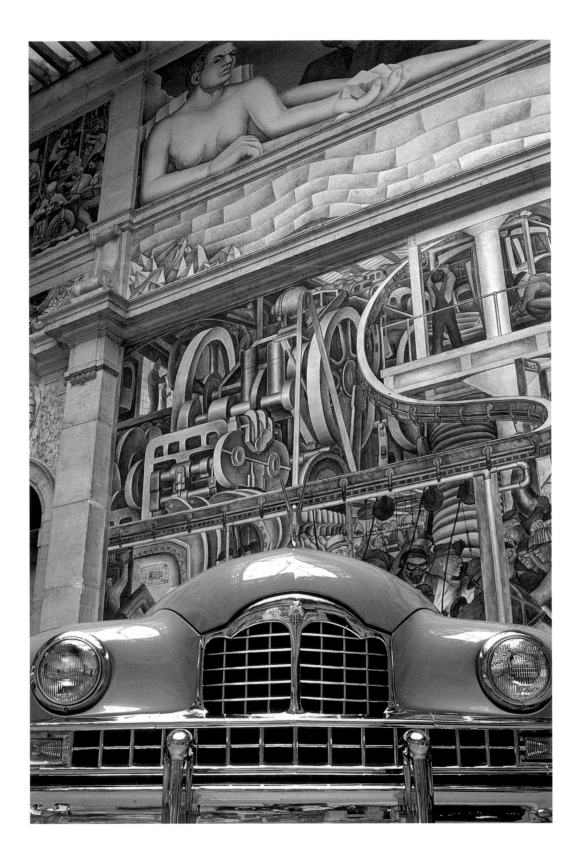

Balthazar Korab • **CAR IN RIVERA COURT** • Color Photograph • 41" x 24" • Level Two

Internationally known photographer Balthazar Korab began his training as an architect. He continued his studies of art history at the Louvre in Paris and worked with renowned twentieth century architects Le Corbusier, Eero Saarinen and Minoru Yamasaki. This photograph depicts the Rivera Court at the Detroit Institute of Arts.

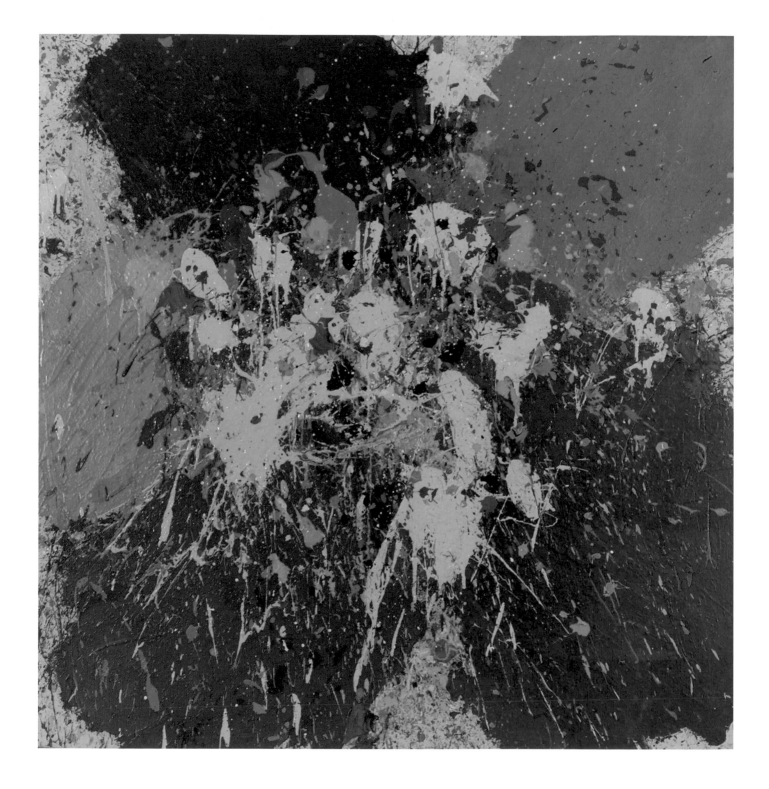

Vassely Ting • **BLUE EYED GRASS WITH OPEN YELLOW MOUTH** • Oil • 60" x 60" • Level Two

Vassely Ting is a well-known California artist. This work was donated to DRH and the DMC board of Trustees by Holland Hudson, a cousin of the J. L. Hudson family. This painting is much admired by patients who declare "It's modern art!" Gift of Holland Hudson.

Valerie Parks • **STRANGE PARADE** • Oil on Linen • 33" x 51" • Lower Level

Detroit artist Valerie Parks is a Wayne State University graduate, NEA recipient, a member of the Education Department of the Detroit Institute of Arts and a Founding Member of the Forum of Contemporary Arts at the DIA. Her painting addresses beauty and politics at the same time. "Strange Parade" is musical and mesmerizing. The juxtaposition of the repetitive figures against a background of festive lights recreates the excitement of Broadway lights.

Unknown Artists · **MASK SERIES** · Level Two

African masks played a major role in rituals, ceremonies and tribal initiations. Often the white-face masks were used to represent the soul of an ancestor or to ward off evil spirits. These masks were purchased in Johannesburg, South Africa but are available throughout Central Africa. The boxes and the framing give them a ghost-like appearance and they create a powerful presence in the area.

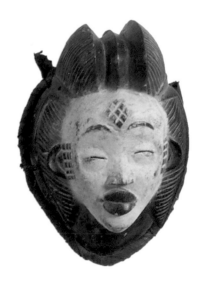

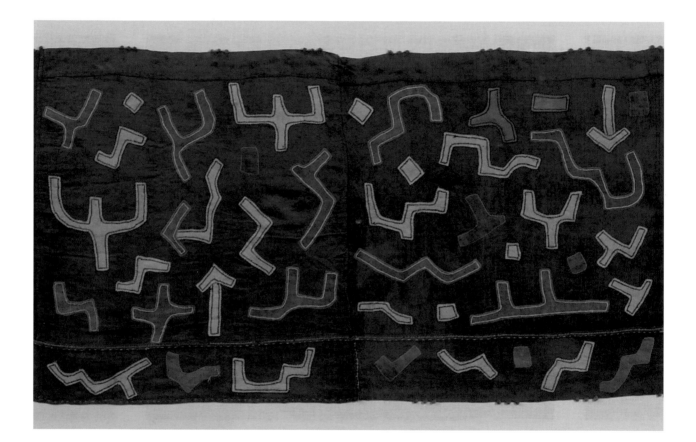

Unknown Artist · **KUBA CLOTH** · Applique/Textile · 55" x 93" · Main Corridor

Kuba Ngeende Dance Dress. The intricate applique "patches" originally repaired holes, before they were developed into traditional design motifs. This style of pattern originated in Ka Ndabele. The long intricately embroidered cloths display beautiful earthtone colors and wrap around the body many times for dancing.

Allie McGhee • **UNTITLED** • Mixed Media on Canvas • 49" x 48" • Level Two ER Waiting

This work is an example of McGhee's mature work, in which he favors an expressive style with sweeping brushwork and thick layers of pigment that give texture to the canvas. This mixed media work was part of the "Visual Paradox 98" exhibition at the George N'Namdi Gallery in Detroit and was included in the emergency department's 2004 expansion project.

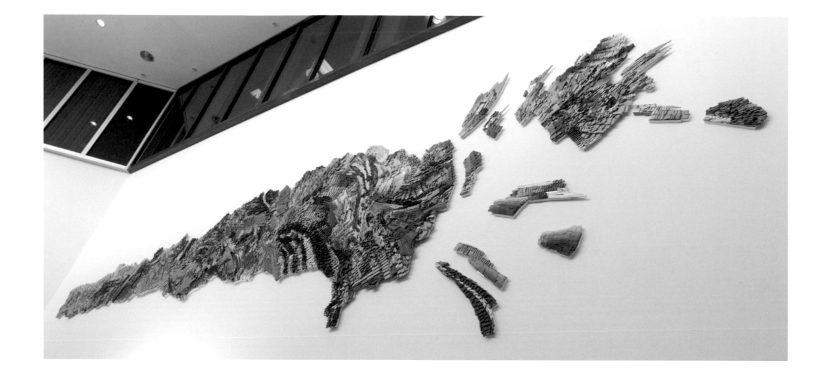

Glen Michaels • **GALAXY** • Assemblage • Level Two ER Waiting

This assemblage is a portion of a mural that was donated by Comerica Bank for Detroit Receiving Hospital's new Emergency Room. The assemblage, inspired by the surge and flow of the many waterways in Michigan and including occasional sharp-angle crystaline effects symbolizing Michigan's many rich mineral deposits, was originally installed in Detroit's Renaissance Center as part of a 163 foot continuous wall. It was relocated to this site thanks to the generosity of Comerica Bank and with the assistance and dedication of Lisa DiChiera, Milton Zussman, Ken Maurin & sons of Artpack Services and Irene Walt. The original assemblage was divided into sections, two of which are installed at DRH, with others at Henry Ford Hospital, the Shifman Library, the Lande Building, and an upcoming installation in the Wayne State University Common Room. Donated by Comerica Bank.

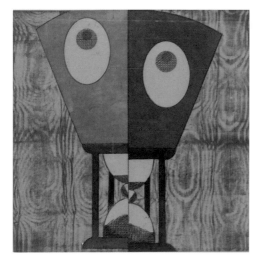 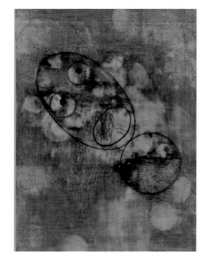 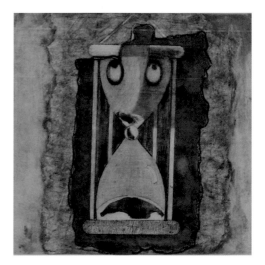

(Left) Lindsay Walt · **BIG EYES 10-OCT** · Print · 28" x 30" · Level Four

(Middle) Lindsay Walt · **TWO EYES 11-MAY** · Print · 25" x 30" · Level Four

(Right) Lindsay Walt · **SAND CLOCK 9-JUN** · Print · 28" x 30" · Level Four

Lindsay Walt is a New York artist who trained at the Rhode Island School of Design and the School of the Art Institute of Chicago. Her work has been extensively exhibited in galleries and museums in New York City. The technique used in these three prints is hard ground etching. In this series of etchings, anthropomorphic objects allude to the passing of time. Series donated by Dr. & Mrs. Alexander Walt.

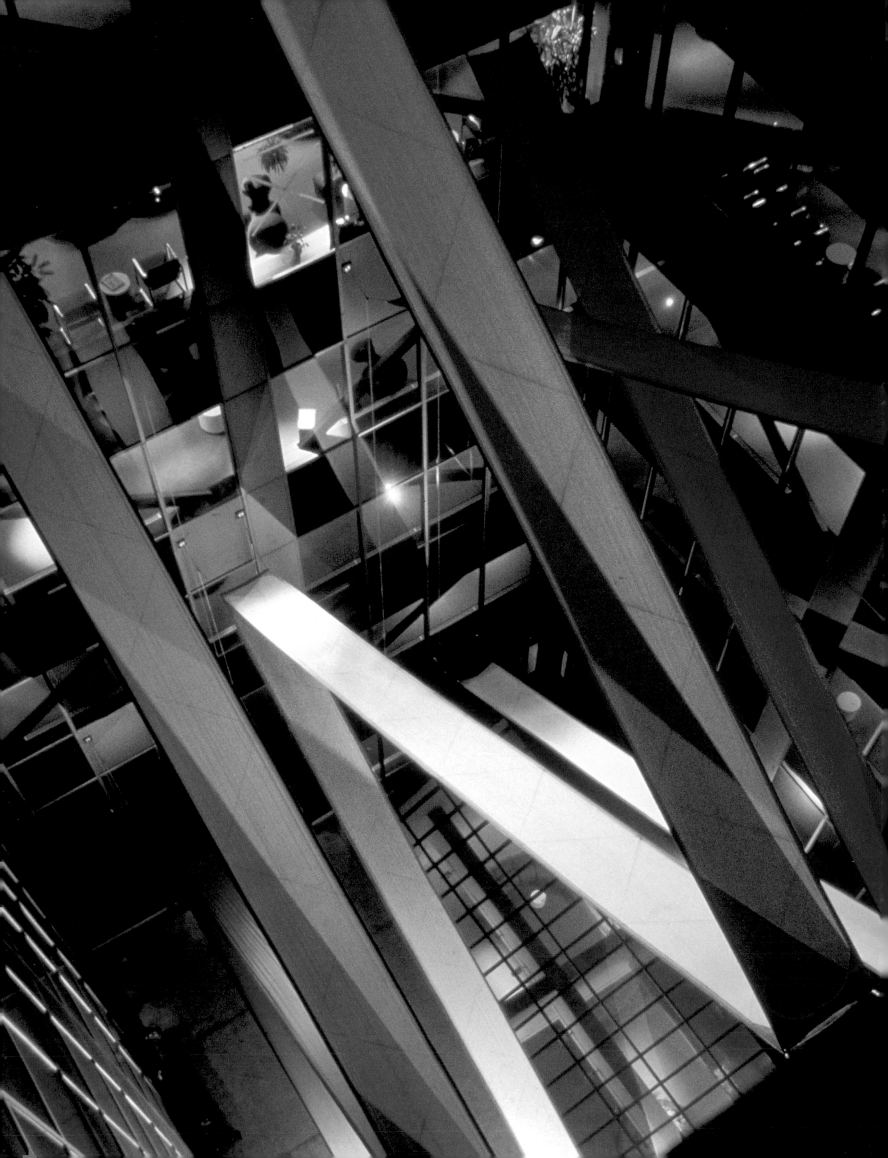

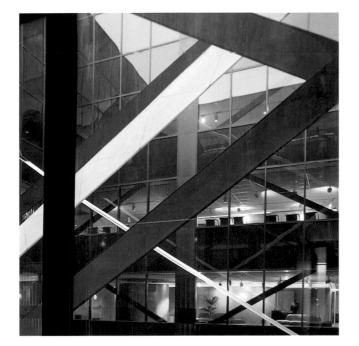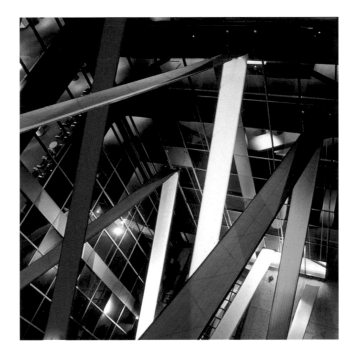

Anne Healy · **COLOR CROSS SECTION** · Fabric · Six Story UHC Courtyard

Ann Healy was one of the early feminist artists/sculptors and often worked in sailcloth or canvas. This lively piece is composed of nine sixty-foot panels of multi-colored vinyl sailcloth. Each panel moves diagonally through the seven-story courtyard in the health center: the entire system is fastened directly to the building structure and is visible from every angle. This was the first work of art commissioned by the DRH Art Commission. This site-specific work changes with the sunlight and creates a colorful contrast to the building. The National Endowment for the Arts, the Michigan Council for the Arts and the Wayne State University Fund funded this work in 1979.

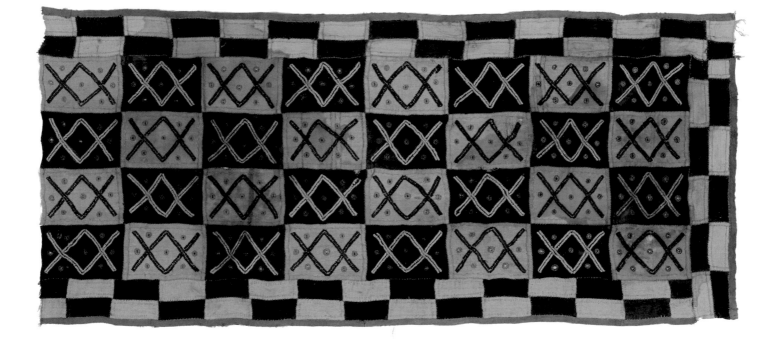

Unknown Artist • **SHOWA/KUBA CLOTH** • Textile • 35" x 47" • Level Two Corridor

It is believed that in the early colonial days Kuba artists would borrow black dyed ribbons from typewriters to create these works of art. Often the weavers have tattoos on their upper bodies echoing the patterns of the fabric. These textiles often came from the Belgian Congo.

Adam Thomas · **ABSTRACT COMPOSITION WITH GREEN & RED** · Oil · 62" x 60" · Level Four

This bold abstract painting by Detroit artist Adam Thomas creates a joyful island of color through its geometric composition and evocation of the natural world. A vibrant blue dominates the painting with a clear red in striking contrast; these colors seem to jump out of the canvas.

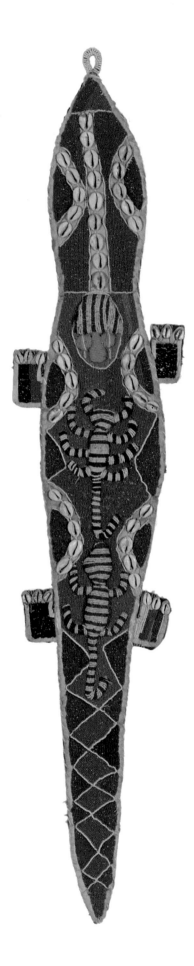

Unknown Artist • **YORUBA BELT** • Beads/Textile • 58" x 16" • Level Two Corridor

These belts were often hung on the wall at the entrance to a Yoruba home.

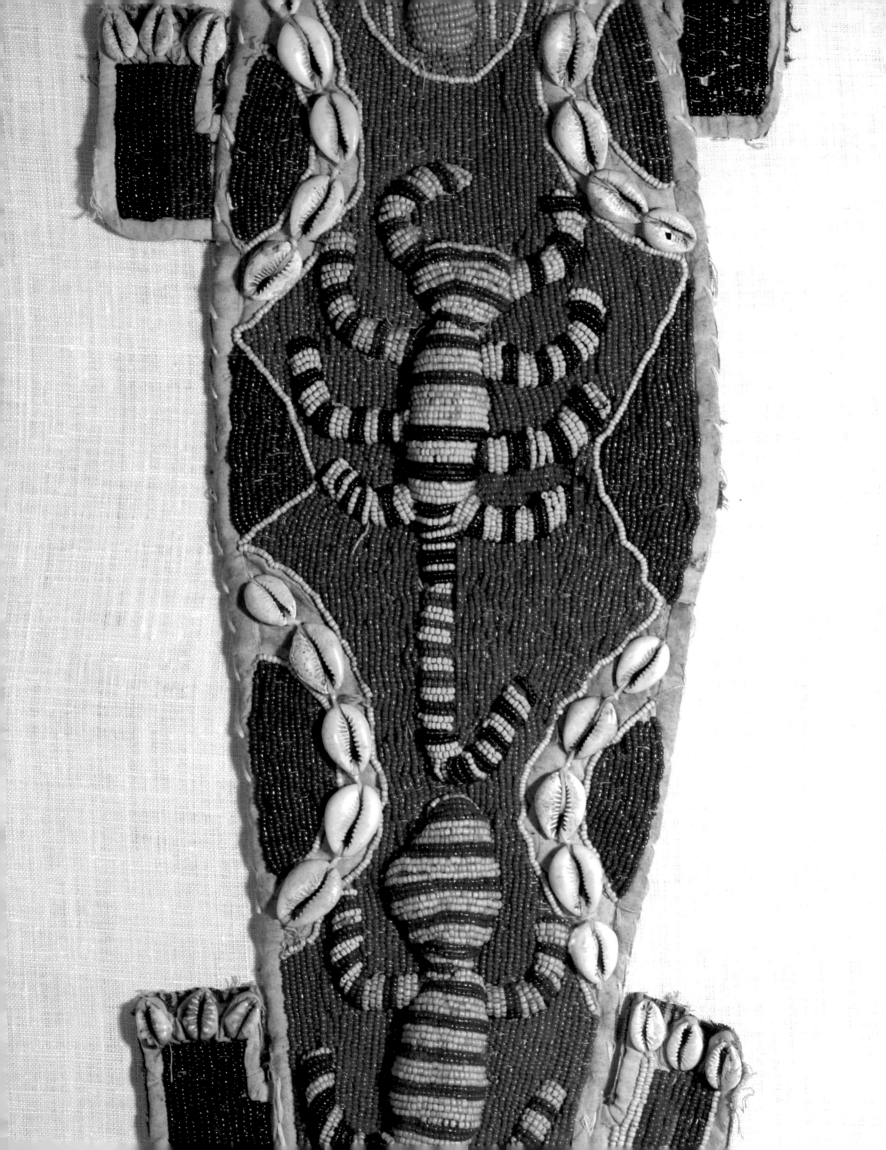

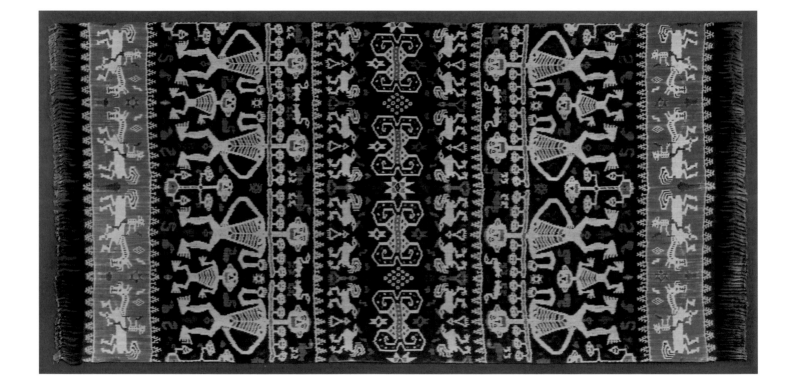

Unknown Artist • **HINGGI** • Textile • 56" x 105" • Level Two

One of two types of Subanese textile from Indonesia, the hinggi is worn by the men. Hinggi are often made in pairs, one to be used as loincloth and the other as shoulder cloth. The imagery is prestige based, using symbols of wealth and power. Donated by Crittenton Hospital.

Unknown Artists • **AFRICAN BEADED WORK** • Beaded Materials • Main Lobby

The Ndebele created magnificent beadwork of every description. In ceremonial aprons, the motif was always the home or the house. The wall hangings and belts portrayed people in everyday life with the border covered in Cowrie shells. In the past century, beads of various size and quality were brought by Europeans and often exchanged for land. It was said that the African women threaded the cotton through mutton fat to prevent the beads from slipping in the execution of the artwork. Many masks and headpieces were highly decorated with this type of beadwork. The Ndebele regard children as a blessing—God's gift to the family. The dress consists of small front aprons cut into fringe at the bottom.

David Barr • **UNTITLED** • Sculpture Series • (Left, Top) 45" x 45", (Left, Bottom) 41.5" x 43.5", (Above) 54" x 62" • ER Waiting

David Barr is a renowned Detroit sculptor whose work is in the collection of Chrysler World Headquarters, Michigan Library Museum, and Mt. Elliot Park. He is founder and artistic director of Michigan Legacy Art Park in Northern Michigan. These works, some of the most structural and architectural in the collection, have a definite calming effect on patients in the Emergency Room. Series donated by Mr. & Mrs. Fred Erb, Edgemere Enterprises, Inc.

Alexander Calder • **UNTITLED** • Print • 35" x 50" • Level Two

Calder's work re-examined the basic principles of sculpture by defining volume without mass and incorporating movement. He is one of the most innovative artists of the 20th Century. These prints demonstrate Calder's ability to capture the essence of his subject with great economy of line and form. They lend a peaceful presence to their surroundings. Wayne State University Collection gift to the DRH Art Commission.

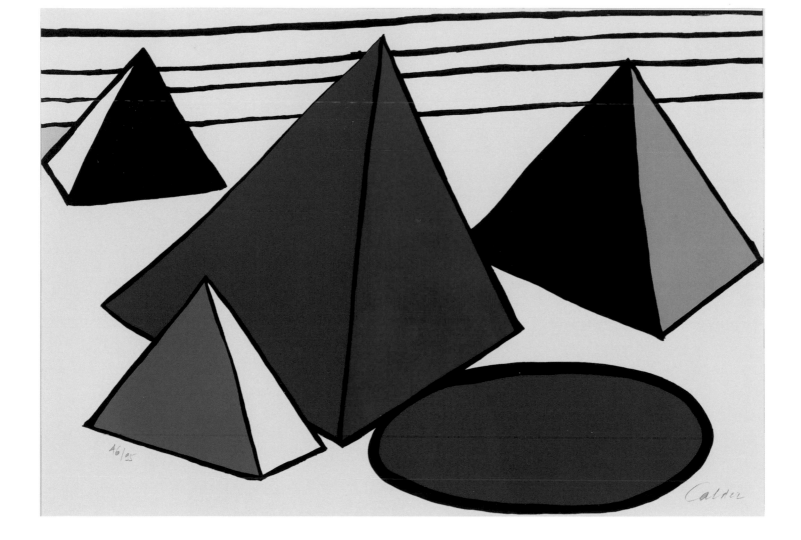

Alexander Calder • **UNTITLED** • Print • 35" x 50" • Level Two

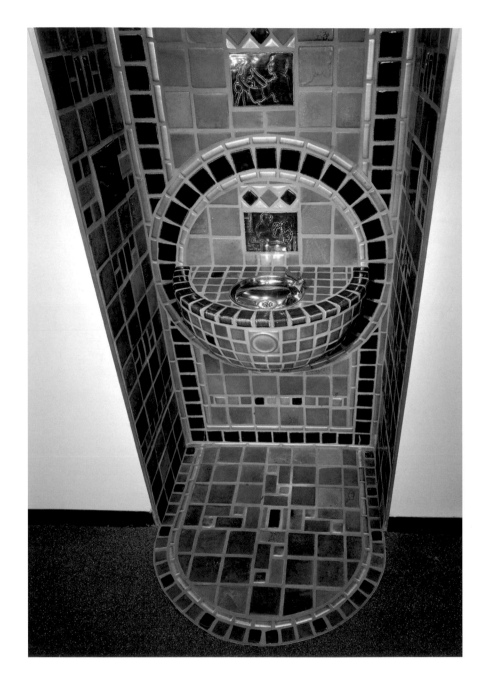

Pewabic Pottery (Designer James Markley) • **FOUNTAIN** (Robert DeDeckere Memorial) • Ceramic Tile • 93" x 51" x 18" • UHC Waiting

The rich green tiles of the fountain were originally fired for the Stroh Brewery in 1955. These green tiles were a gift of the Stroh Brewery to the Art in the Stations project of the Detroit People Mover; subsequently the Art Commission donated the tiles to DRH for the drinking fountain and for the ceramic tile installation "The Arc" (shown on the cover of this book) at the UHC entrance. The Detroit workers — representing the doctor, the pilot, the mother, the mechanic and the teacher — depicted in the five figured tiles were originally designed and created for Detroit's Northern High School, by Mary Chase Perry Stratton in 1926. The navy, blue, and gold tiles were specially fired for this project by Pewabic Pottery. This work was funded by friends of Detroit Receiving and by the DeDeckere family in memory of Robert DeDeckere. The tiles were a gift from Peter Stroh and the Stroh Brewing Company and were used for the Cadillac Station of the Detroit People Mover and for other public art projects.

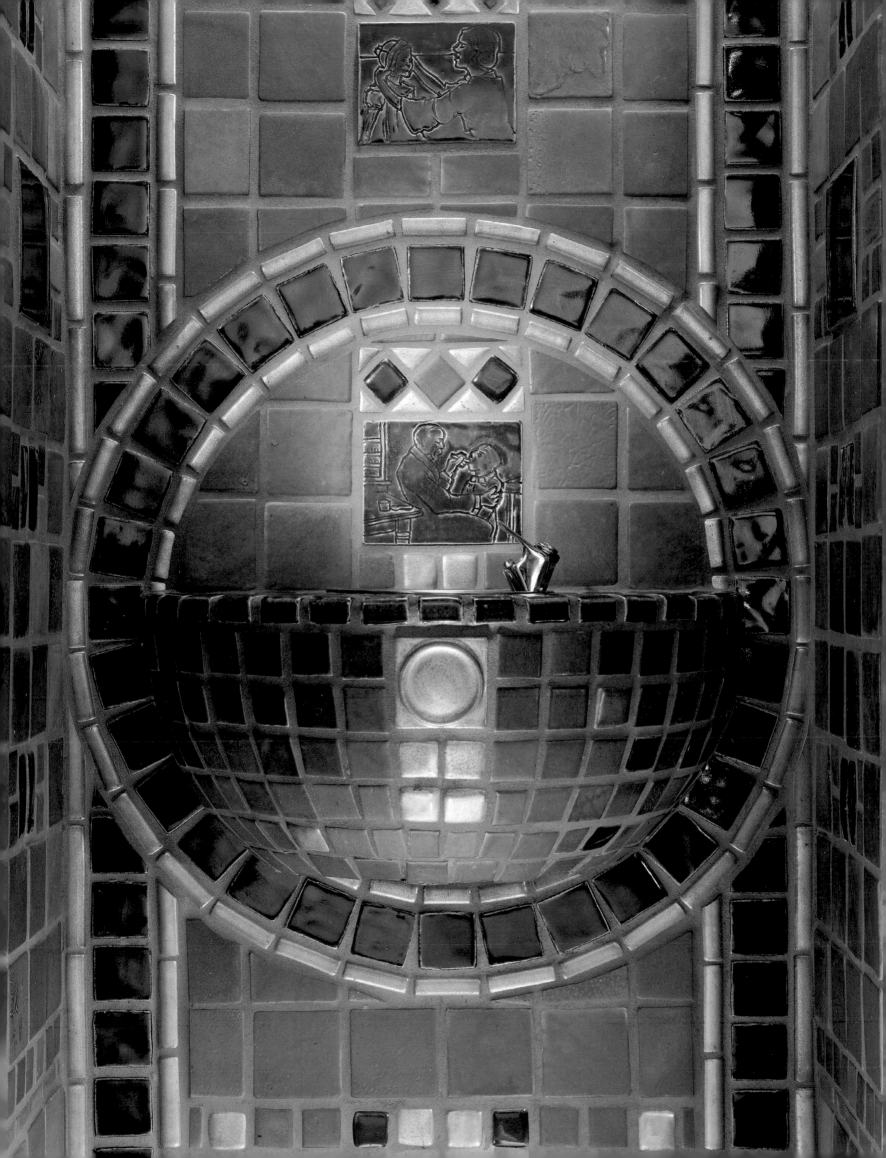

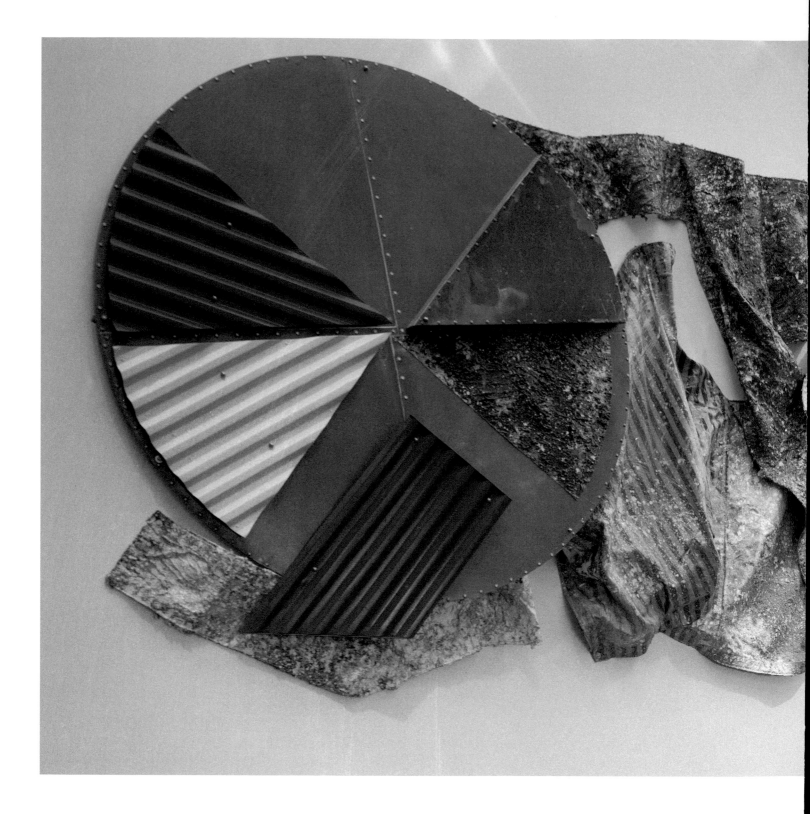

Sam Gilliam • **WAVE COMPOSITION** • Mixed Media • 7' x 36' • Main Corridor

Sam Gilliam's "Wave Composition", is a colorful acrylic painting on two overlapping canvas panels. Various painted metal compo-
nents are integrated into the structure. Gilliam has said that the wave-like rhythm is a translation of the energy found in the hospital
itself. Sam Gilliam created two major installations in Detroit in the same year; "Wave Composition" at DRH and a triptych of colorful
canvases at the McNamara Federal Building. Hawkins Ferry, Tom Harris and Irene Walt went to D.C. to view the work in progress at
the artist's studio, and were on the National Endowment for the Arts Selection Committee when the work was chosen for Detroit.
Gilliam has been influential in the art world since 1966, when he liberated his paint-splashed canvases from their stretchers for the
Corcoran Gallery of Art in Washington, D.C. His work is in major museums and public and private collections nationwide and is the
subject of a forty-year retrospective at the Corcoran Gallery of Art. Funded by the City of Detroit Building Authority in 1980.

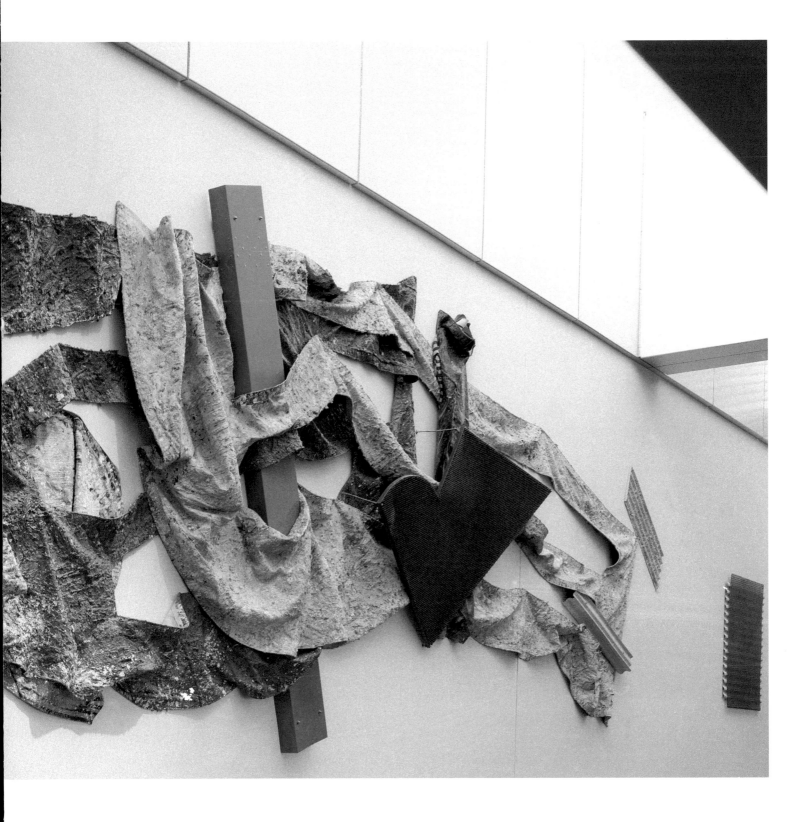

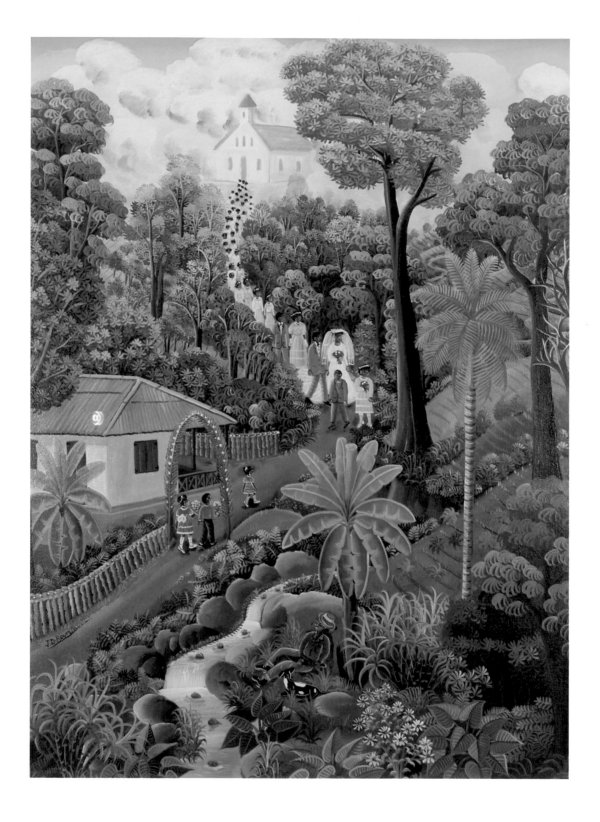

Jean Geriver • **WEDDING** • Acrylic on Canvas • 25" x 37" • Level Four

This Haitian painting, purchased in Jamaica, serves as a joyous reminder of what a wedding might be.

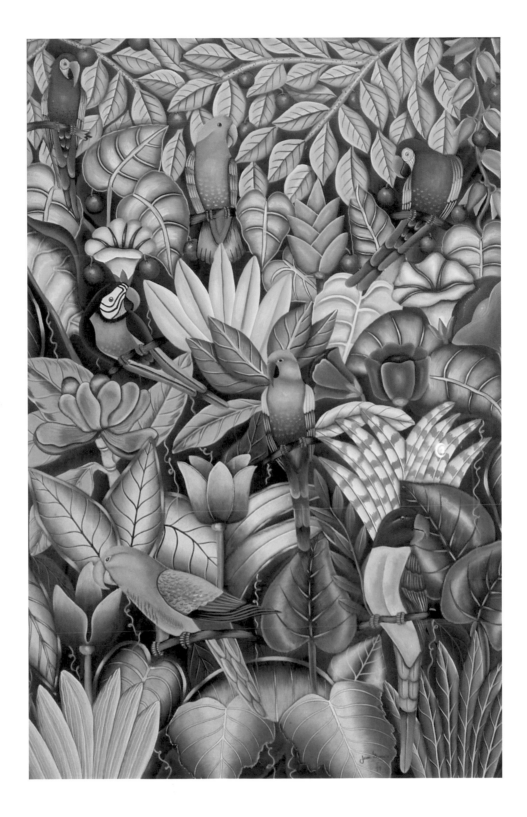

J.D. Borsiqugic • **JUNGLE** • Acrylic on Canvas • 14" x 32" • Level Four

Haitian artist Borsiqugic's paintings are flamboyant and colorful illustrations of the lush Caribbean landscape.

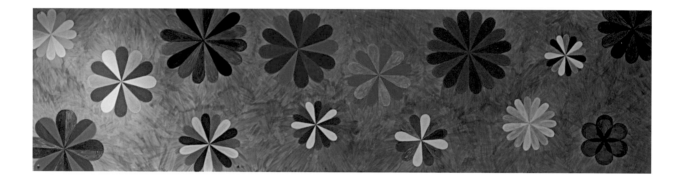

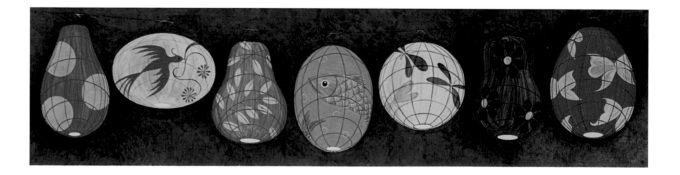

Megan Parry • **UNTITLED** • Acrylic on Dibond • 24" x 96" (ea.) • Psychiatric Unit

Megan Parry has lived in Philadelphia, New York City, Boulder, Colorado and now resides in Detroit. She has created public works at the Fashion Institute of Technology, The School for the Deaf and Blind, and the University of North Colorado. Her work has been exhibited at the Denver Art Museum, Windsor Biennale, the Arnold Klein Gallery and the Suzanne Hilberry Gallery. These mural panels were designed to encourage patients who are confined to this ward to look up and see upbeat colors and beautiful imagery inspired by nature. Funded in part by the Michigan Council for the Arts and Cultural Affairs and the City of Detroit. Funds donated by Benard Mindell.

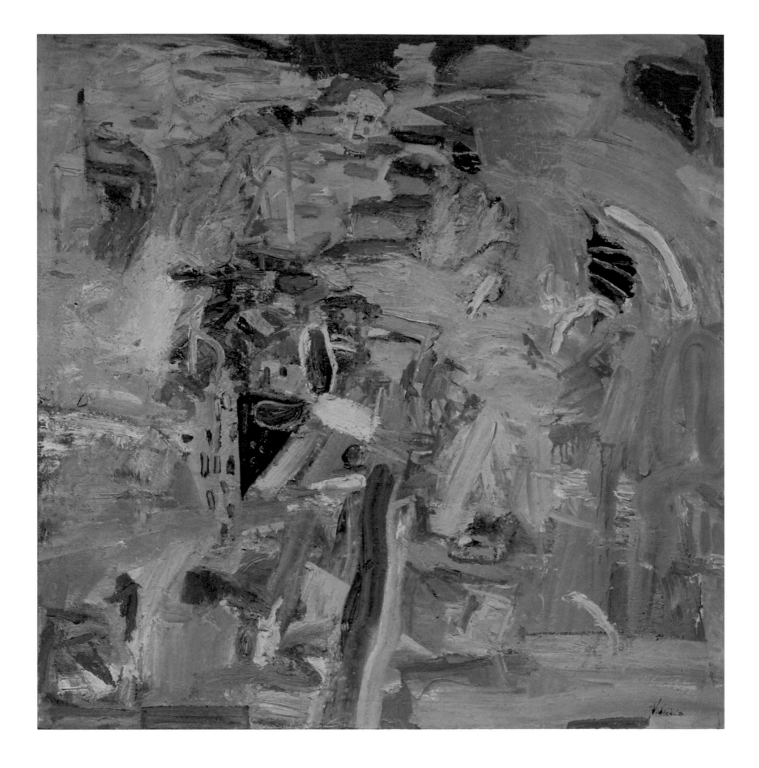

Vidvuds Zviedvis • **DAY IN JUNE** • Oil • 58" x 56" • Level Two Lobby

A young Detroit artist and recent immigrant from Latvia, Vidvuds Zviedvis trained at the College for Creative Studies. His work demonstrates his sensitivity to color and the surrounding environment.

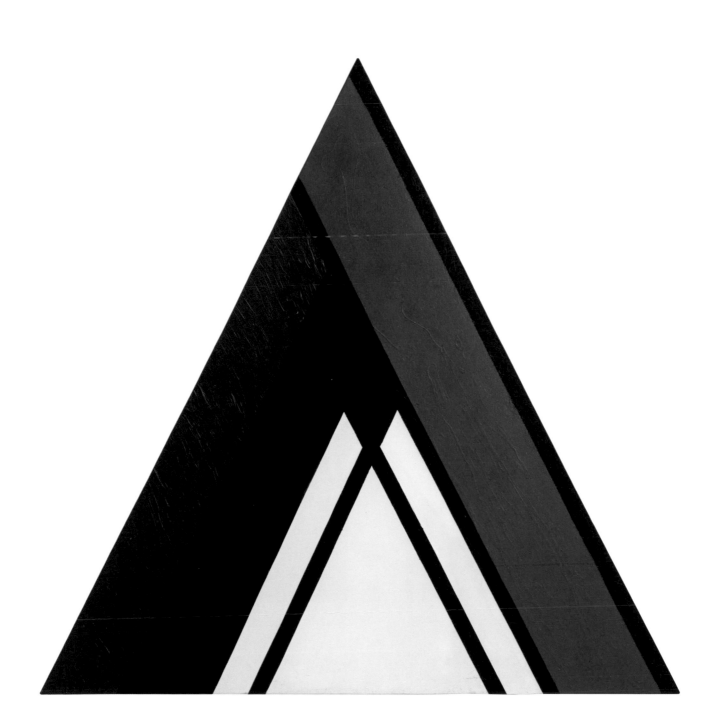

Roy Slade • **TRIANGLE** • Oil • 44" x 44" x 3" • Level Two Café

Roy Slade is Director Emeritus of Cranbrook Academy and Museum of Art. His work is exhibited in public and private collections from South America to England. Gift from Mr. & Mrs. Fred Erb.

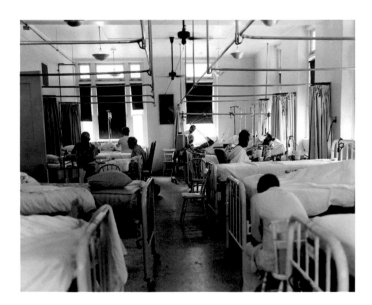

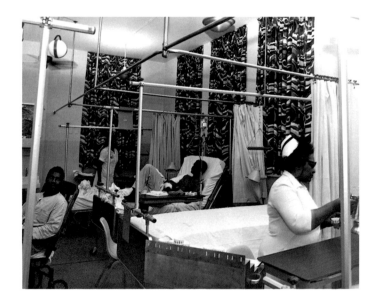

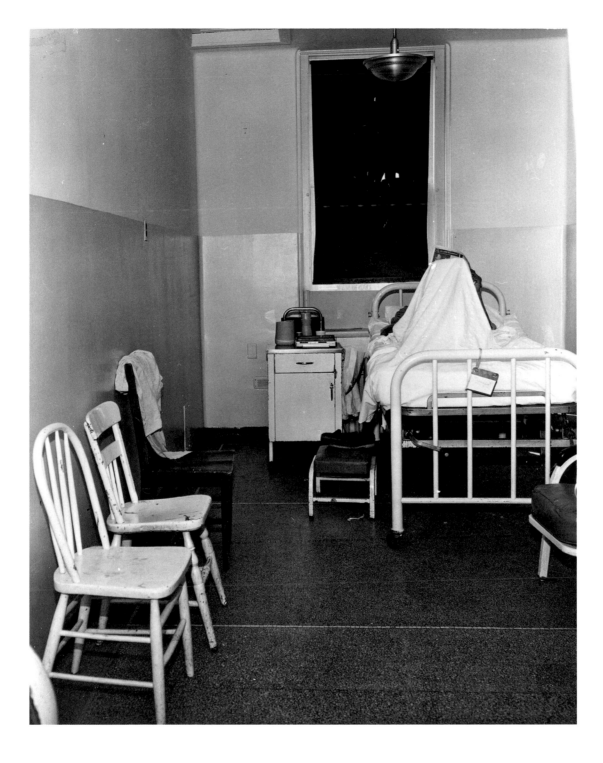

Unknown Artists • **HISTORIC IMAGES** • Black and White Photographs • Level Two

These before-and-after photos of the Old Detroit General Hospital were taken around 1968, and were often used by the administration to document budget concerns to the Board of Health and the Detroit City Council. Dr. Walt used them for several years to display the Wayne State Medical School's deep concern for the welfare of the hospital's patients, and the need for funding.

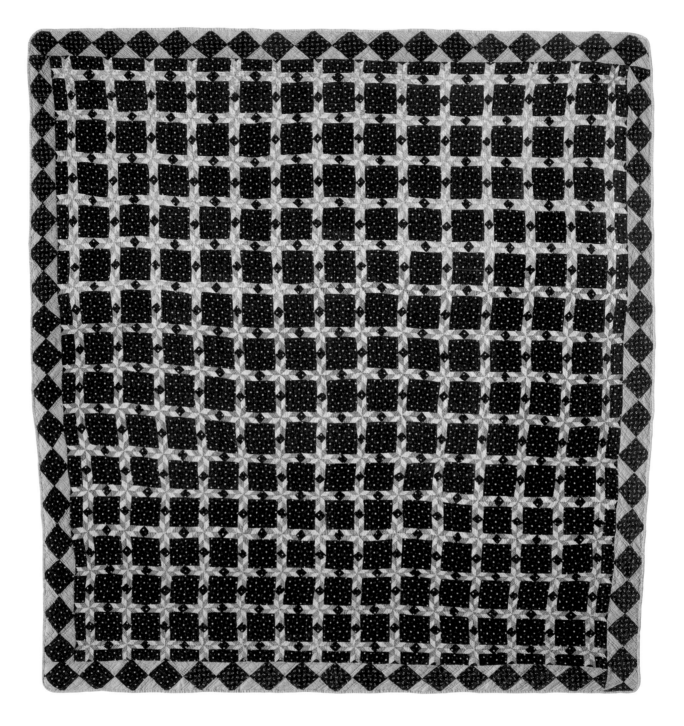

Unknown Artist · **CUPID'S ARROW POINT** · Quilt · 82" x 81" · DRH Entrance

Quiltmaking is truly an American art form, often depicting family or personal history, community life, religious belief, practices and even political views. The date 1880 is embroidered on the back of the quilt. Similar patterns and fabrics used by Ohio quilt makers during this period suggest this to be the place of origin—Its maker is unknown. This is a very traditional quilt; the blue squares were colored with indigo (a dye made in India and very poisonous and later prohibited for import to the US). The pink color was used for the afternoon uniforms of slaves in the South. Slaves were often the ones who sewed these beautiful hand made quilts. A sale of de-accessioned works created a budget to purchase this wonderful work of art. The identical miniature quilt was lovingly created and donated by Dr. Alice Campbell after months of labor.

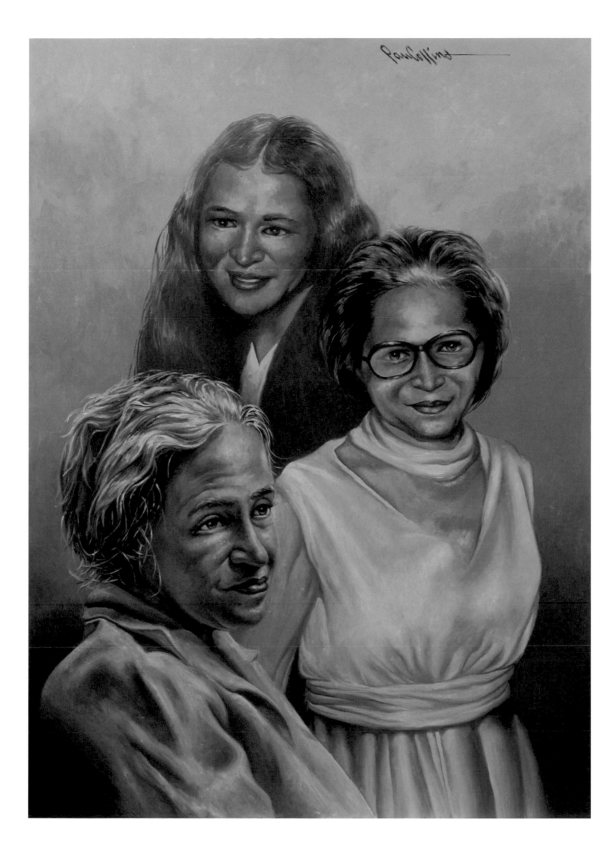

Paul Collins • **ROSA PARKS** • Oil on Board • 68" x 50" • Level Five Rosa Parks Geriatric Center

Paul Collins, whose work reflects American history and culture, lives and works in Grand Rapids, Michigan. He was commissioned to create this monumental work of art commemorating the various phases of the life of Rosa Parks for the Rosa Parks Geriatric Clinic at DRH.

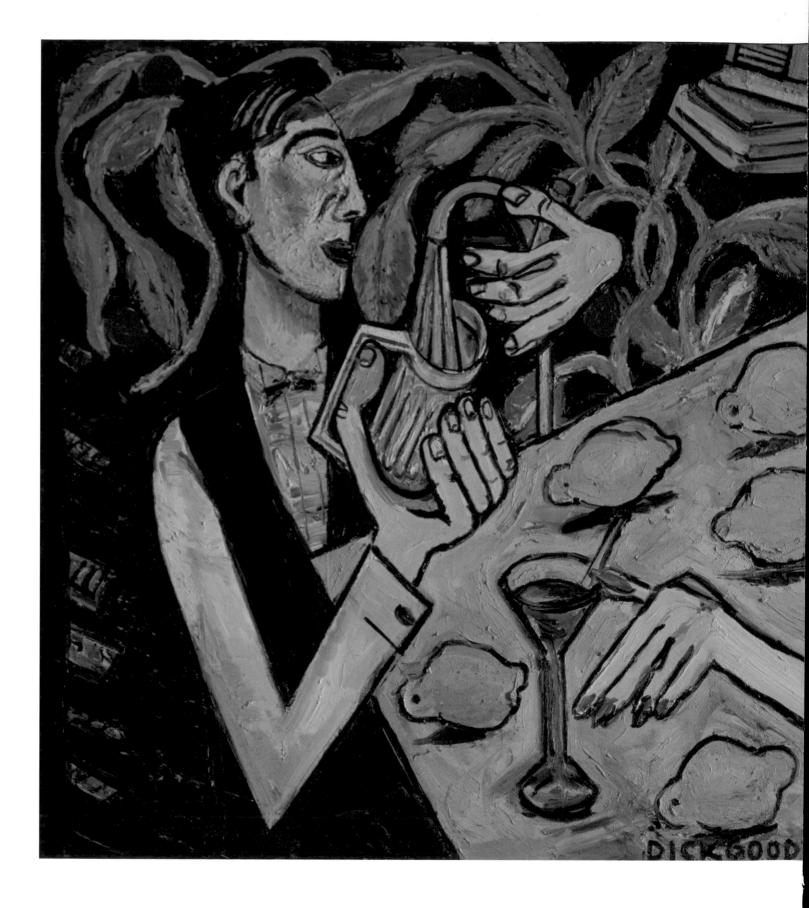

Dick Goody • **CARS WITH BARS & LEMONS** • Oil on Canvas • 60" x 118" • Cafeteria

Detroit area artist Dick Goody was commissioned to create this work in 1988 for the 123 Restaurant in Grosse Pointe. This whimsical and colorful painting is installed in a prominent location in the DRH cafeteria and is seen daily by many people. Donated by Mr. & Mrs. Stanley Day.

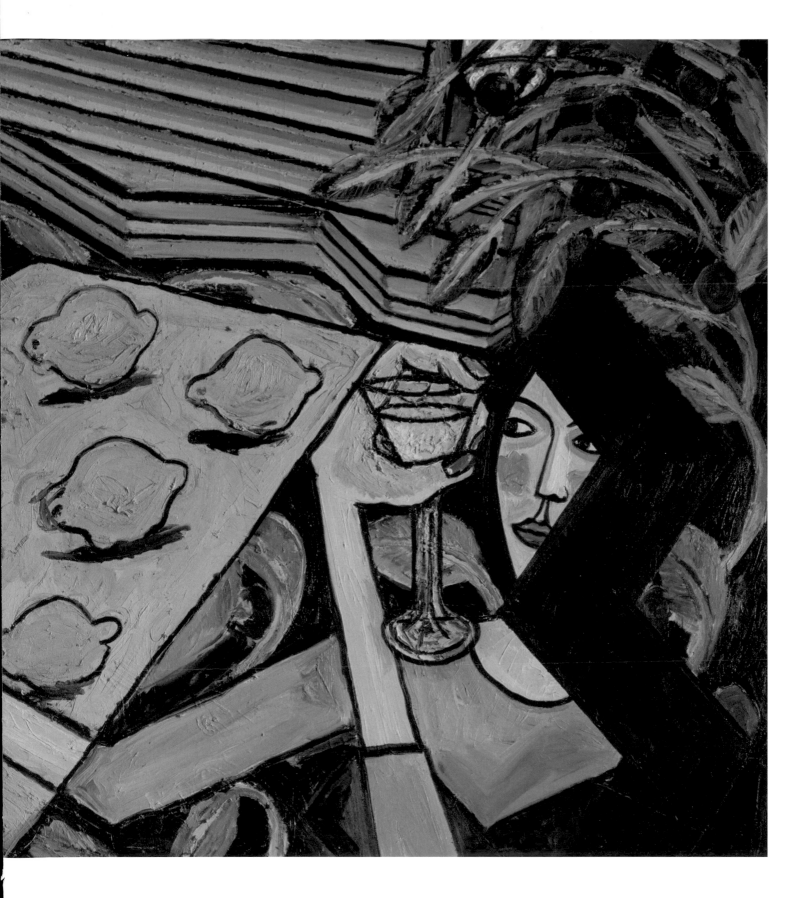

Marcia Freedman • **POD** • Charcoal on Paper • 43" x 46" • Main Corridor

Marcia Freedman calls her work an investigative process using organic form as a metaphor for internal landscapes and external perceptions. "Pod: a protective container or housing, a number of animals clustered together, a husk, jacket, hull, shell, sheath, case, seed vessel. Rooted in the tradition of the figure, it focuses on psychological inwardness, relationships and the human condition. Built of many layers, it is rich in surface and filled with energy. It is a system of mark making, repetition and process between self and materials, revealing an inner dialogue and personal history, yet remaining ambiguous and indistinct."

Erik Gamble • **BEDSPREAD** • Oil • 67" x 96" • Level Two Lobby

The work of Canadian artist Erik Gamble is provocative and elegant. This painting is located in the main waiting area and creates a bold color statement opposite Glen Michaels' white & silver assemblage. Gift of Andrew and Gayle Camden.

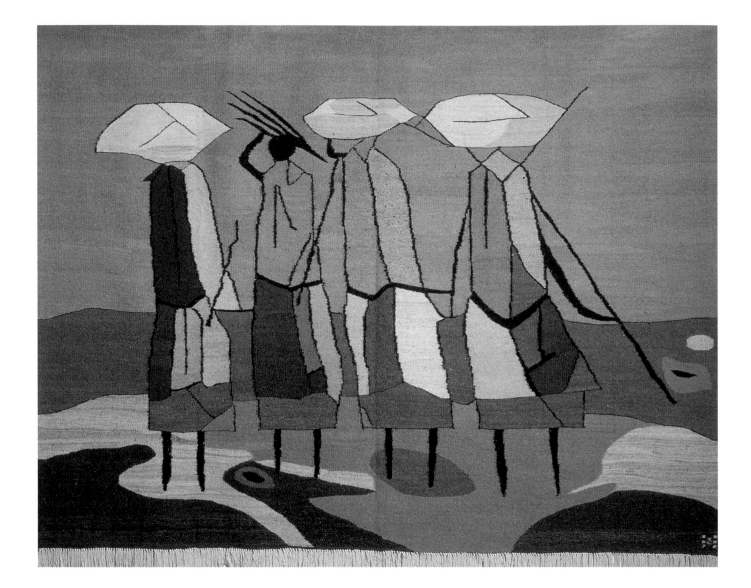

Solomon Sekhaolelo • **FOUR LESUTO PEOPLE** • Mohair Tapestry • 92" x 118" • Hospital Lobby Waiting

Soloman Sekhaolelo was raised in Soweto and is self-taught. This tapestry, made of mohair and Karakul wool in earth colors typical of the area, depicts four people; three women and a man of Lesuto origin. The women bear all the burdens and clothes on their heads and the man carries light fire wood sticks. Tapestries of this kind represent an important visual chronicle of village life in Africa and are shown in museums and art galleries throughout the world. Sekhaolelo's tapestries, clay sculptures, chalk drawings and paintings are much sought after. He is an Ndebele, a proud and artistic tribe of people, who decorate their houses with colorful paintings and create lovely bead works as well as traditional African art, such as tribal aprons, pipes and joy sticks. Purchased in Johannesburg by Irene Walt.

Marjorie Hecht Simon • **FLOWERS** • Watercolor • 48" x 36" • Level Three

Marjorie Hecht Simon is a Detroit artist well known for her watercolors of garden scenes. Simon donated the first work of art—a painting of boats in Charlevoix—to the DRH collection in 1968 when the Friends of Detroit Receiving Hospital Committee was formed. The DRH has since received over sixty of her paintings.

Douglas Bulka · **READ BEARINGS** · Print · 23" x 52" · Level Three Administration Hall

Douglas Bulka, a well known Detroit artist, trained at Wayne State University and is on staff in the Graphic Arts Department at the Detroit Institute of Arts. The inspiration for this print comes from specific freeway interchanges around Detroit. The work becomes a space where nature was at one time forced into artificial order, but now has established its own order/reality. The artist has created an other-worldly experience through the use of bright colors and sharp lighting effects.

Jenny Kilimi • **UNTITLED** • Color Photograph • 48" x 72" • UHC

Artist Jenny Kilimi was born in Athens, Greece and was trained in England and at Eastern Michigan University. Her work has been exhibited internationally. This work was donated by her former professor, Charles McGee, after Ms. Kilimi 's death in 2006.

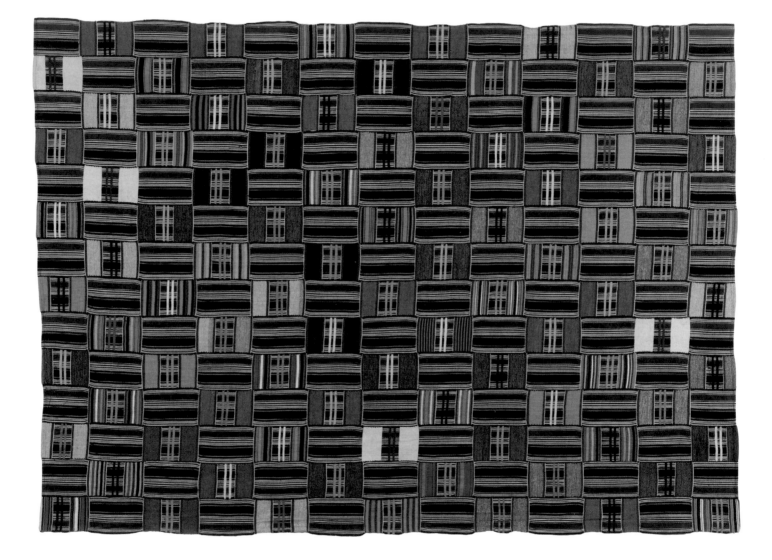

Unknown Artist · **KENTE CLOTH** · Textile · 55" x 93" · Level Two Hospital Lobby

Fine Kente cloth was handmade in Ghana, woven into strips and sewn together. Since the 1960's, the popularity of these textiles has increased; many fine examples are in museums around the world. Kente is a symbol of African identity, and is often used in royal regalia, festivals and ceremonies. Kente developed in the late Seventeenth Century, although the roots of African weaving date back to 3,000 B.C. Rich with symbols and colors, Kente cloth forms a language that communicates ideas. Yellow represents regality and spirituality; blue conveys harmony, and green fertility and rejuvenation.

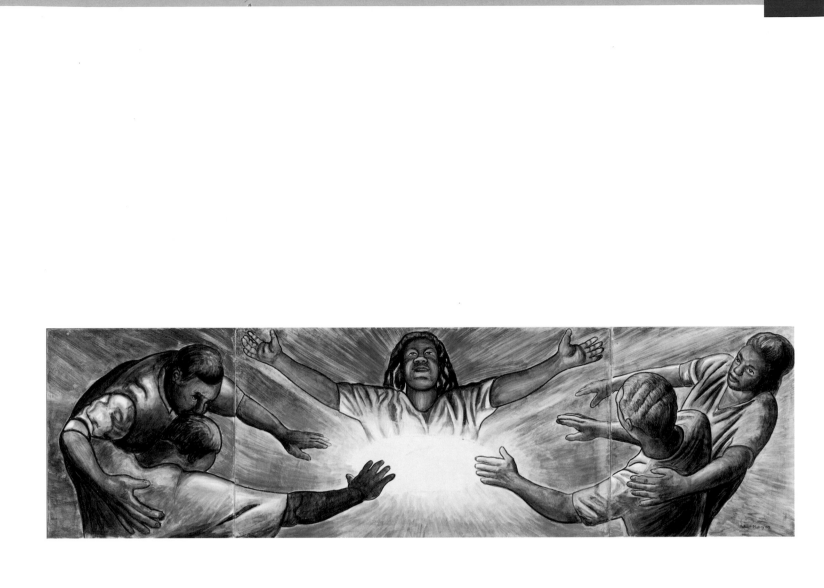

Hubert Massey • **HEALING** • Fresco • 4' x 12' • Physiotherapy Department

This fresco panel, using the traditional fresco technique, is a site specific work of art created for the Physical Therapy Department. This project was funded in part by the National Endowment for the Arts, Challenge America Grant; a grant that supports projects that extend the reach of the arts to underserved populations. Massey's work is driven by a desire to create art that is available and reflect all communities.

Massey studied art at Grand Valley State University and the Slade Institute of Fine Arts at the University of London. In 1994 he was selected to participate in a fresco workshop facilitated by Lucienne Bloch and Stephen Dimitroff, apprentices to the famed Mexican muralist Diego Rivera whose "Industry" frescoes grace the walls of the Detroit Institute of Arts. Massey has been commissioned to created frescos for the Detroit Athletic Club, Flint Institute of Arts, The College for Creative Studies, Grand Valley State University and Charles Wright Museum of African American History. Massey has almost single-handedly brought the centuries-old art of the fresco into the 21st century.

Index of Artists

Thank You

The Detroit Receiving Hospital Board of Trustees, physicians and staff wish to convey our deepest gratitude to the following individuals who, through their very generous gifts, made *The Healing Work of Art* possible:

Acknowledgements

PRESIDENTS
Mr. Alfred Plotkin, President
Mr. Elliot Roberts, President
Mr. William A. Himmelsbach, President
Mr. Edward Thomas, President
Mr. Les Bowman, President
Dr. Iris Taylor, President

FRIENDS OF DETROIT RECEIVING HOSPITAL
Irene Walt, Chair
Sally Mayer
Mary Alice Keast
Moses Kelly Fritz
Norman Fink
Grovenor Grimes, DRH Administrator and Author of
 History of Detroit Receiving Hospital

ART COMMISSION FOR NEW DETROIT RECEIVING HOSPITAL
Lee Hoffman, Art Advisor
Olya Dworkin, Joint Chair, Wayne State University
Richard Biliatis, Wayne State University, Art Department
Dr. Dewey Moseby, Curator of European Art, Detroit Institute of Arts
William Kessler, Architect, William Kessler & Associates
Irene Walt, Joint Chair, Detroit Receiving Hospital
Dr. Harold Gardner, M.D., Appointed by Dean, Wayne State University

PHOTOGRAPHERS
Balthazar Korab
Robert Hensleigh
Robert Stewart
Timothy Thayer

ADDITIONAL SUPPORT
Sue Marx – Video "Seven Artists Seven Spaces"
Dr. Scott Dulchavsky – gift of creation of CD of Detroit Receiving
 Hospital Art Collection
Butler Graphics
Dr. Charles Lucas, Detroit Receiving Hospital Surgical Alumni
Dr. Anna Ledgerwood, Detroit Receiving Hospital Surgical Alumni
Dr. Donald Weaver, Department of Surgery, Wayne State University
Laura Rodwin, Volunteer Advisor

The Detroit Medical Center